IMAGES
of America

OMAHA'S HISTORIC
HOUSES OF WORSHIP

ON THE COVER: By 1876, Omaha was growing into a city that boasted numerous businesses as well as the headquarters of the Union Pacific Railroad. Two years later, Union Stock Yards opened and Creighton University was founded. This photograph demonstrates Omaha's rapid growth in less than a decade. (Courtesy of the Omaha Public Library.)

IMAGES
of America
OMAHA'S HISTORIC
HOUSES OF WORSHIP

Eileen Wirth, PhD, and Carol McCabe

Carol McCabe
Eileen Wirth

ARCADIA
PUBLISHING

Published by Arcadia Publishing
Charleston, South Carolina

Printed in the United States of America

Library of Congress Control Number: 2014949028

For all general information, please contact Arcadia Publishing:
Telephone 843-853-2070
Fax 843-853-0044
E-mail sales@arcadiapublishing.com
For customer service and orders:
Toll-Free 1-888-313-2665

Visit us on the Internet at www.arcadiapublishing.com

*In memory of the pioneers who planted the seeds of
both faith and tolerance in Omaha, Nebraska.*

CONTENTS

ACKNOWLEDGMENTS

We wish to thank many people, religious congregations, and other organizations for their assistance in researching this book and loaning us valuable historical photographs. Everyone we turned to was unfailingly helpful, and we are grateful to all of you. This book is YOURS, although any errors are strictly ours.

We are especially indebted to the Omaha Public Library for supplying us with about half of the photographs and a great deal of caption material, to say nothing of the large amounts of reference assistance. This book literally would not have been possible without the great help of Martha Grenzeback of the local history department. Thanks also to reference librarian Lynn Sullivan, many of whose original captions have been edited or adapted for this text. Her research is reflected on countless pages of this book. Special thanks also to library director Gary Wasdin for his support and flexibility, which allowed this project to proceed.

While a great many of Omaha's historical congregations contributed heavily to this book, we are especially grateful to the Rev. Michael Gutgsell, pastor of St. Cecilia's Cathedral, and development director Beth Klug for allowing us to use the amazing photographs of the cathedral that Al J. and Ione Werthman shot for the parish's 75th-anniversary book. Material for captions for our extensive St. Cecilia's section also came from that book.

Here is a list of other congregations and organizations that contributed photographs and information to this book: First United Methodist Church, St. Mary Magdalene's Church, Kountze Memorial Lutheran Church, Trinity Episcopal Cathedral, Creighton University and archivist David Crawford, First Central Congregational Church, First Unitarian Church, Clarkson College, Sacred Heart Catholic Church, St. John's Greek Orthodox Church, Temple Israel, First Baptist Church, First Presbyterian Church, Boys Town, the Jewish Federation of Omaha and its wonderful library, the Douglas County Historical Society, and Finegold Alexander + Associates Inc., Architects. We apologize for not naming the individuals connected with all these groups who assisted us, but you know who you are!

Special thanks to Vera Mercer for the use of her scanner and other assistance, and to the staff of Arcadia Publishing for inviting us to do this project and assisting us through the process.

INTRODUCTION

From today's dazzling Omaha Riverfront area, with its parks, hotels, bars, restaurants, arena, and pedestrian bridge to Council Bluffs, it is hard to envision the location as a muddy village clinging to the banks of the Missouri River in the 1850s. Indeed, drinking, gambling, and other vices were so prevalent that a Kansas City newspaper once suggested that the nation pray for Omaha.

In today's Omaha, it is hard to drive six blocks without seeing a house of worship of some variety. It is estimated that more than half of the population belongs to a congregation, which is higher than the national average. Many of both the historic and new houses of worship offer visual hints to the cultures of the people who built them.

Who would expect to see an elephant atop a Hindu temple or Orthodox cupolas in a Midwestern city? For that matter, how did one of the nation's 10 largest cathedrals come to be built in a city that had less than 200,000 people at the time construction began?

This book explores the fascinating story of how these and many other religious buildings and related landmarks came into being. It takes readers on a photographic tour of Omaha's historic houses of worship, including tales of the people and groups that built them. Although many early Omaha congregations came and went and some preachers gave up on the community, church steeples began to dot the downtown Omaha landscape a few years after its founding in 1854.

Early Omahans established a religious culture that endures to this day. From the first, the city was religiously diverse, and this is reflected in the wide range of historic church buildings depicted in this book. No one faith dominated, although Roman Catholics were, and remain today, the largest religious group.

Because Omaha's settlers were diverse and had to find a way to live together, they tended to be religiously tolerant. Until churches could be built, for example, Catholics, Episcopalians, and Methodists all held services in the territorial capitol building. After Catholics built the city's first church, they shared an organ with the Episcopalians who met in a nearby commercial building. Men from the two congregations carried it back and forth weekly. This spirit of cooperation has endured.

The historic houses of worship featured in this book also reflect the city's history of immigration, especially in South and North Omaha, where the architectural styles of many churches are physical reminders of the people who built them. South Omaha, especially, features an eclectic collection of churches of many faiths and national heritages, reflecting the diversity of immigrants who came to work in the packinghouses. North Omaha attracted its own diverse collection of African Americans, Irish, Scandinavians, Germans, and Jews, with all of these heritages reflected in historic houses of worship.

This book reflects on the influx of many of these groups into Omaha and the contributions they made by featuring their houses of worship as well as related institutions, such as a small historic Jewish cemetery in North Omaha.

Our work owes much of its inspiration to the late Dr. Charles Gildersleeve, a University of Nebraska at Omaha geography professor who used to fascinate audiences with his slide shows on

the city's ethnic landmarks, including religious buildings. He explained that it was possible to trace the movements of various groups around the city by looking at such architectural clues.

As a young religion reporter at the *Omaha World-Herald*, coauthor Dr. Eileen Wirth developed a special interest in the richness of the city's religious and ethnic heritage and the beauty of many of its historic churches. Coauthor Carol McCabe has deep roots in an ethnically diverse South Omaha family and a special love for this historic part of the city.

Our research included driving the streets of the old neighborhoods of South and North Omaha hunting for historic churches. We scoured books on Omaha history and often stumbled across unexpected treasures or historically interesting tidbits that fleshed out the portrait that began to emerge.

This book takes a roughly chronological approach to the development of Omaha's religious landscape, beginning with the historic Mormon Winter Quarters settlement in the Florence area before Omaha was founded. Settlers en route to Utah spent a couple of awful winters in the area, and many died, leaving behind the Mormon Pioneer Cemetery.

In presenting the story of the growth of religion in Omaha, we focus especially on the "First" churches of half a dozen denominations, many of which are still located either in or near downtown Omaha. In order to ensure that Omaha's major faith traditions are all represented, we pay special attention to the earliest houses of worship of various groups regardless of when they were founded. Inevitably, we have omitted some congregations that might have been included; we apologize for such omissions.

We also focus on houses of worship listed in the National Register of Historic Places and those that have local landmark status. Buildings that were designed by important architects are also spotlighted. We especially highlight St. Cecilia's Cathedral, not only because it is the city's most prominent religious landmark, but also because it houses a spectacular collection of original art created for this gem.

Since it is impossible to separate religious buildings from those who built and worshipped in them, we attempt to show some of the flavor of the neighborhoods in which they are located and how these areas developed. We acknowledge significant religious institutions and some interesting people from the groups who built Omaha.

In our final chapter, we skip ahead to the present and the way that today's newcomers are expanding Omaha's religious diversity with houses of worship of many new faiths, a high percentage of them non-Christian.

We hope you enjoy this visual tour and that you may even be inspired to check out some of its stops!

One

FROM MORMONS TO JESUITS

Since its founding in 1854, Omaha has welcomed newcomers of all varieties, from the early Irish immigrants who helped build the Union Pacific Railroad to today's Hispanics, East Asians, and people from the Middle East.

All have left their imprints on the city's landscape through their houses of worship—everything from an Episcopal cathedral with Tiffany glass windows to a mosque and a Baha'i temple. This would have surprised the Rev. Joseph Barker, an English immigrant who came to Omaha in 1856, describing it as "a few huts, two or three decent houses, a bank, the State House, a saw mill, and a few stores . . . To us it had a somewhat hideous appearance."

This changed, but all local histories agree that the infant community was not very religious. Methodist Peter Cooper organized the city's first congregation in 1854, holding services in the territorial capitol for his six-member flock. In 1856, Omaha acquired its first church building, St. Mary's Catholic Church, at Eighth and Howard Streets east of today's Old Market. According to one estimate, only about 10 percent of early Omahans were church members, compared with a little over half today.

Nevertheless, by 1860, the city had added seven more churches: First Methodist Episcopal, First Congregational, Trinity Episcopal Church, German Methodist Episcopal, Presbyterian, First Baptist, and Emmanuel Lutheran (later Kountze Memorial Lutheran Church). In addition, Florence, then a separate community, had its own Presbyterian church, as did Bellevue.

As the city grew, so did the number of congregations of many faiths. St. John's African Methodist Episcopal (AME) Church became the city's first African American congregation when it opened in 1867, and Temple Israel became the city's first Jewish congregation in 1871.

Today's Omaha includes about 300 houses of worship representing all major Christian faiths as well as congregations of Mormons, Unitarians, Jews, Hindus, Muslims, Buddhists, and Baha'is. Tolerance has generally been a hallmark of the city's religious climate.

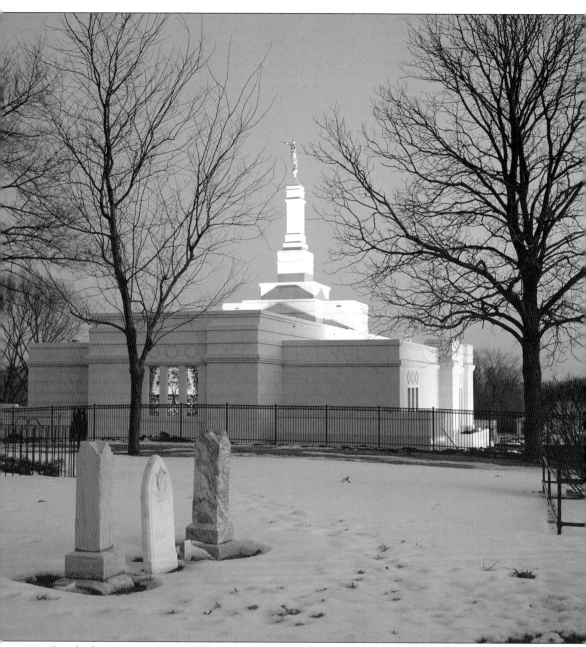

Omaha has a strong Mormon heritage dating to the movement of persecuted Mormon settlers from Illinois to Utah. In 2001, the Mormon Church dedicated the Winter Quarters Nebraska Temple in the historic area. It is one of three temples built in locations of historic significance to the early church. The other two are in Palmyra, New York, and Nauvoo, Illinois. The Bethel white granite structure is 16,000 square feet in size and is adjacent to the Pioneer Winter Quarters Cemetery. (Courtesy of the Church of Jesus Christ of Latter-day Saints.)

This map of the trail the Mormons followed includes Winter Quarters in North Omaha, where the Church of Jesus Christ of Latter-day Saints built a major interpretive center in 1997. The center also memorializes important regional sites such as Kanesville, Iowa. (Courtesy of the Church of Jesus Christ of Latter-day Saints.)

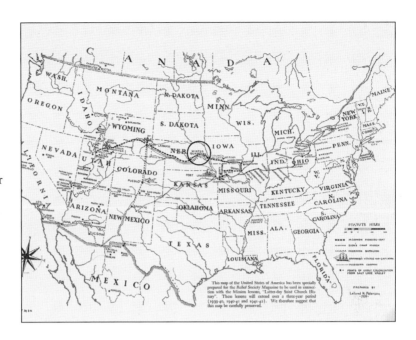

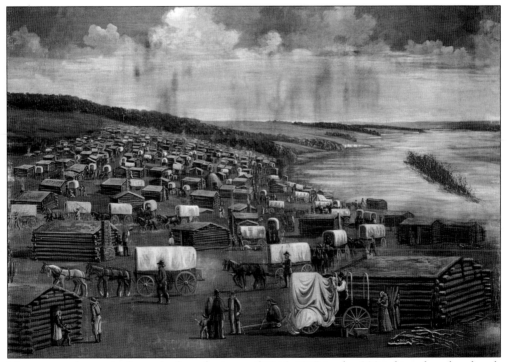

Mormon settlers waited out the brutal winter of 1846–1847 in the 800 cabins that the church built in today's Florence area. The Winter Quarters complex housed 2,500 settlers en route to Utah. The encampment, shown in this drawing, overlooked the Missouri River near present-day Thirty-third and State Streets. (Courtesy of the Church of Jesus Christ of Latter-day Saints.)

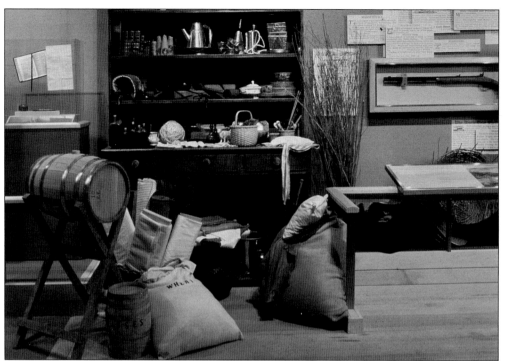

Historic Winter Quarters is a site on the Mormon Pioneer National Historic Trail run by the National Park Service. At today's museum there, visitors can see artifacts similar to those that the Mormon pioneers used on the westward journey and during their winter stay at the encampment. (Courtesy of the Church of Jesus Christ of Latter-day Saints.)

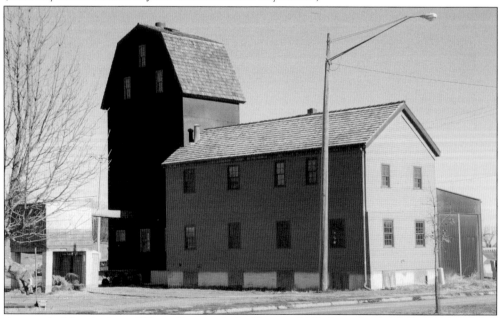

Among the historic sites at Winter Quarters is the Florence Mill, shown here, which survives. Other historic sites in the Winter Quarters area include the Mormon Pioneer Memorial Bridge, Florence Park, the Mormon Pioneer Cemetery, and Cutler's Park. (Photograph by Carol McCabe.)

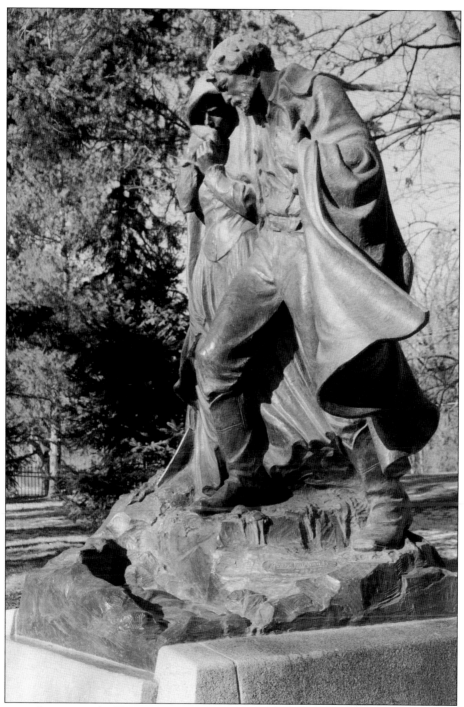

This noted statue at the Winter Quarters Historic Site pays tribute to the hundreds of settlers who died of malaria, scurvy, dysentery, and other diseases during the winter of 1846–1847. The Mormons abandoned Winter Quarters in 1848 in response to government pressure to leave Indian lands. The Mormon Church then relocated those who had not gone west to Kanesville, today's Council Bluffs, Iowa, on the east bank of the Missouri River. (Photograph by Carol McCabe.)

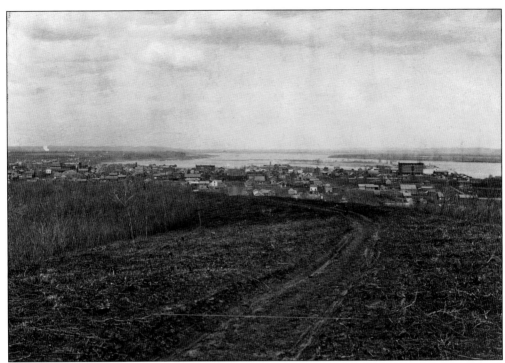

Methodists held Omaha's first religious services in 1854, when the Rev. Peter Cooper of Council Bluffs preached the city's first sermon on August 13. The next spring, the Rev. Isaac Collins organized a Methodist Society, but, by September, he had enlisted only six members. It was years before Omaha would be more than a muddy village, as can be seen in this photograph taken in 1866 looking north from South Eleventh Street. (Courtesy of the Omaha Public Library.)

St. Mary's Catholic Church, at Eighth and Howard Streets, was organized in 1855, and its building opened in 1856. At the time, Omaha had only about 20 Catholic settlers and no priest. Acting governor Thomas B. Cuming purchased two lots for the church, although he was a son of an Episcopalian minister. His wife, Margaret, was a Catholic. St. Mary's was the only church of any denomination at the time. (Courtesy of St. Mary Magdalene's Church.)

The first Nebraska territorial capitol was located on Ninth Street between Farnam and Douglas Streets. Church services for several denominations were conducted in the legislative chamber—Methodists in the mornings, Congregationalists in the afternoon, and Baptists in the evening. This photograph shows the second territorial capitol, built in 1857–1858 on the site of today's Central High School. (Courtesy of the Omaha Public Library.)

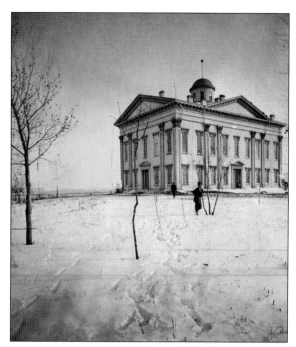

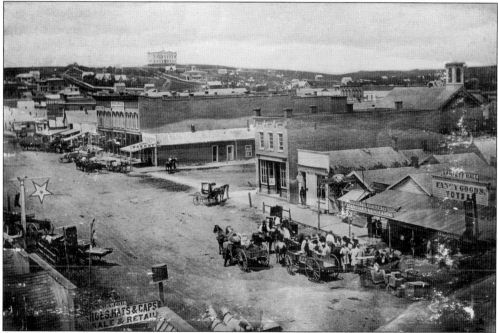

Farnam Street between Eleventh and Twelfth Streets was called the Pioneer Block. Before Omaha's Episcopalians built their first church, Trinity Church, they held services in 1857 in various rooms on the block. Trinity Church shared an organ with St. Mary's Catholic Church, at Eighth and Howard Streets, which men carried between the two locations for services. This photograph from approximately 1867 shows the Nebraska territorial capitol on the horizon. The steeple of the First Methodist Episcopal Church, located on Thirteenth Street, is seen behind the Champion Bakery building. (Courtesy of the Omaha Public Library.)

Today's Kountze Memorial Lutheran Church was organized in 1858 as Emmanuel Lutheran Church, the first Lutheran church in the Nebraska Territory. It dedicated its first building at Twelfth and Douglas Streets in 1862. These two photographs show views of the church and its parsonage. The second building (below) was constructed at Sixteenth and Harney Streets and named in honor of the family of Augustus Kountze, an Omaha banker who helped found the congregation. (Both courtesy of Kountze Memorial Lutheran Church.)

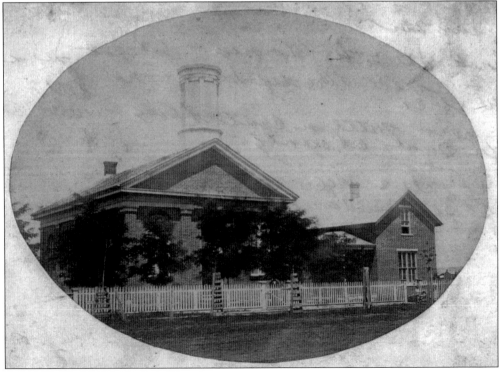

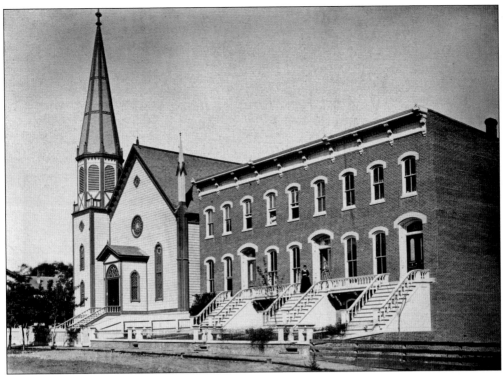

One of Omaha's oldest continuing Protestant congregations, First Central Congregational Church organized in 1855 and constructed its first building at Sixteenth and Farnam Streets in 1857. The congregation later moved to its building on the northeast corner of Nineteenth and Chicago Streets. This photograph shows the church in about 1870, a white wooden building with a prominent steeple. (Courtesy of the Omaha Public Library.)

Trinity Episcopal Church opened its first building, at Ninth and Farnam Streets, in 1859. In 1867, it purchased its current site, at Eighteenth Street and Capitol Avenue, building a wooden church that burned down in 1869. It then built this simple frame chapel that it used for more than a decade until it began building the current cathedral. (Courtesy of Trinity Episcopal Cathedral.)

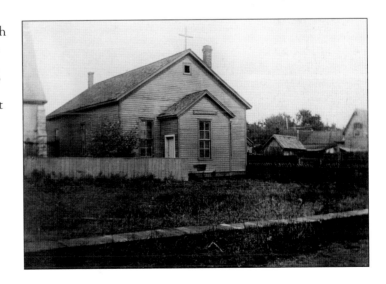

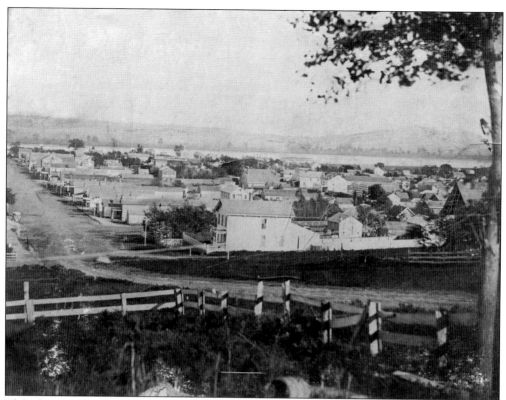

This photograph looks southeast from Seventeenth and Farnam Streets in 1865. Omaha in this era was a wide-open town noted for its bars, gambling, and 61 houses of ill repute. A Kansas City editor wrote that he was not certain Omaha was a fit subject for an editorial, but that he could think of no better subject for the nation's prayers. (Courtesy of the Omaha Public Library.)

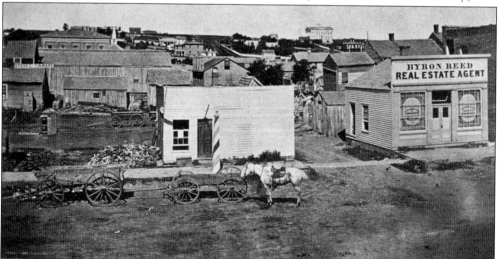

This 1868 photograph of downtown Omaha shows the First Congregational Church spire, a few stores, and the territorial capitol building, where Central High School is now located. In 1868, the city had about 20 churches of various denominations serving a population of less than 16,000. (Courtesy of the Omaha Public Library.)

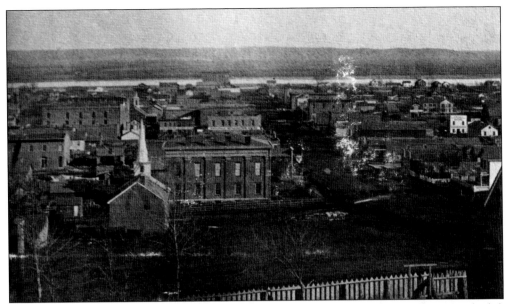

This 1866 photograph shows the First Congregational Church and the first courthouse in the left foreground, looking east on Farnam Street from Seventeenth Street. The Rev. Reuben Gaylord, who founded the church, vividly described Omaha's defects in an 1856 letter to his family back east. He wrote that Omaha had a smaller percentage of religious believers than any community he had ever known. There was a fearful amount of drinking and Sabbath breaking. It was hard to interest people in the gospel because they were preoccupied with the increase in their property values. (Courtesy of the Omaha Public Library.)

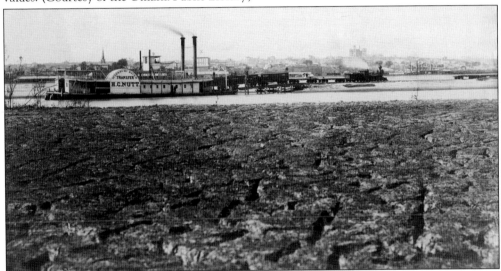

In this photograph from about 1869, a Chicago & North Western train is serving the *H.C. Nutt* steamboat. This view looks almost straight west from the foot of Farnam Street. The new high school is replacing the old territorial capitol building on the hill at the right. Union Pacific has taken over the Herndon House/International House Hotel (the three-story building in the center of the image with an X above it) as its headquarters, at Ninth and Farnam Streets, where it would remain until 1910. To its left is St. Philomena's Catholic Cathedral, which opened in 1868 and is another landmark. (Courtesy of the Omaha Public Library.)

First Methodist Episcopal Church, which first held services in the territorial capitol, had several locations, including this building on Seventeenth Street constructed in 1869. It eventually moved to its fourth building, at Twentieth and Davenport Streets. The Spanish Romanesque structure was dedicated on May 17, 1891. It was made from red sandstone quarried near Lake Superior. The tower at the northwest corner rose to 125 feet. The property was valued at $125,000 in 1895. Fire destroyed the First Methodist Episcopal Church in February 1954. The photograph below shows the fourth building of the First Methodist Episcopal Church. (Both courtesy of the Omaha Public Library.)

The Rev. George Bergren organized First Presbyterian Church in 1857, but the congregation disbanded in 1860 due to financial difficulties. The Second Presbyterian Church succeeded it a few months later. Services were held in different churches, the courthouse, and other locations until it moved to its new brick church at Seventeenth and Dodge Streets, shown here. The original Second Presbyterian became the First Presbyterian Church in 1887. The building was sold to Arthur Brandeis and vacated by the congregation on May 26, 1915. (Courtesy of the Omaha Public Library.)

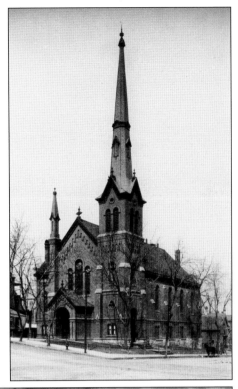

Just a block away from the First Presbyterian site, Brandeis built his iconic department store at Sixteenth and Farnam Streets, shown in this postcard. As downtown Omaha became the city's retail center, some early churches moved to the perimeter of downtown. Brandeis was Omaha's largest local department store for several generations. (Courtesy of the Omaha Public Library.)

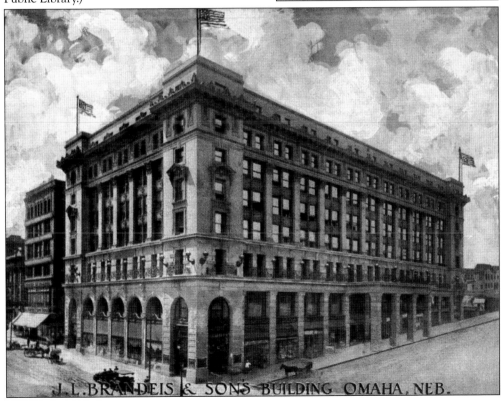

J.L.BRANDEIS & SONS BUILDING OMAHA, NEB.

The German Catholic Church, on the northwest corner of Sixteenth and Douglas Streets, shown here in about 1868, illustrates the way that immigrant groups pouring into Omaha brought not only their religious heritage but also their ethnic and linguistic heritages. For generations, Omaha has had some parishes designated to serve members of various ethnic groups. (Courtesy of the Omaha Public Library.)

St. Mary Magdalene's, Omaha's surviving downtown Catholic church, was founded in 1868 by Father Otto Groenebaum and a dozen German families. It was originally called "the German Church" or "the Doll Church" because of its small size. The little brick church was dedicated on Christmas Day 1868. The "Doll Church" was destroyed by fire on February 3, 1894. A new church was rebuilt on the same site but sold 10 years later. The present St. Mary Magdalene's, at Nineteenth and Dodge Streets, was begun on March 15, 1902, and dedicated in the fall of 1903. (Courtesy of the Omaha Public Library.)

This postcard shows St. Mary Magdalene's before street work required its reconstruction. (Courtesy of the Omaha Public Library.)

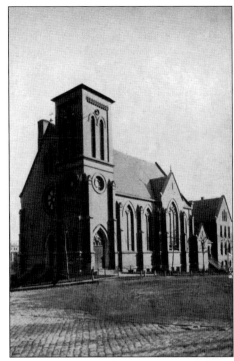

In 1919, city crews cut down the steepness of Dodge Street, Omaha's main thoroughfare, to make it more conducive to traffic. The work, shown here, required the rebuilding of St. Mary Magdalene's Church. (Courtesy of St. Mary Magdalene's Church.)

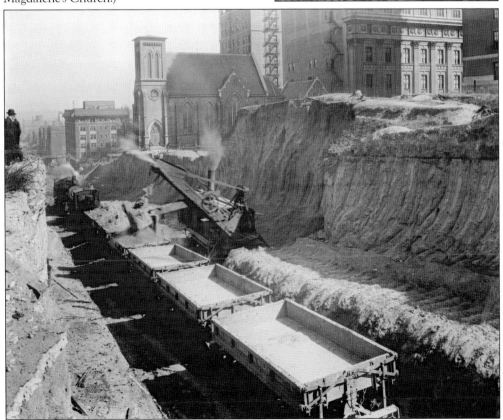

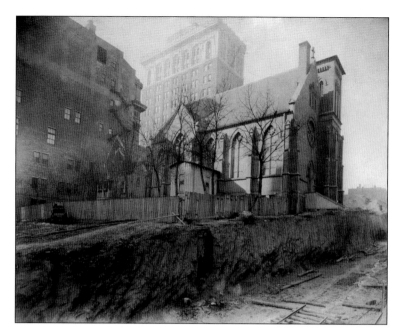

After the street work, St. Mary Magdalene's built "down." The street level of the church became its mezzanine, and a whole new substructure had to be constructed. The work was completed by Christmas 1920. (Courtesy of St. Mary Magdalene's Church.)

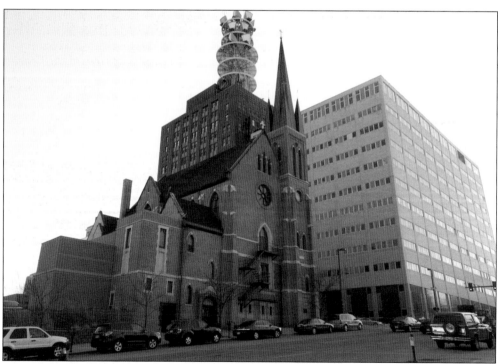

This modern shot of St. Mary Magdalene's Church shows the original doors, near today's fire escape. This photograph faces Dodge Street. The current main entrance is on Nineteenth Street. (Photograph by Carol McCabe.)

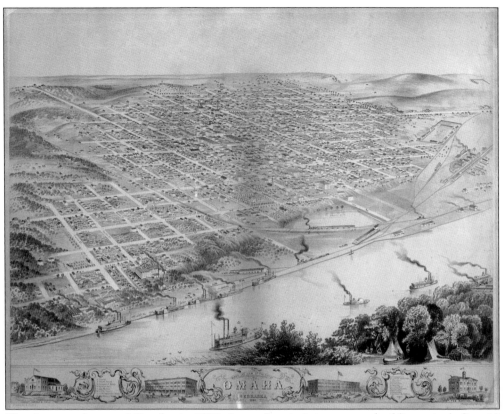

This historical map of Omaha in 1868 shows the city's important buildings, including 10 churches—numbers 9–19 on the legend at the bottom of the map. (Courtesy of the Omaha Public Library.)

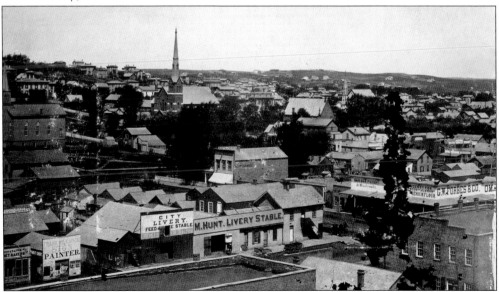

Downtown Omaha is pictured here in 1876, illustrating the city's rapid growth in less than a decade. (Courtesy of the Omaha Public Library.)

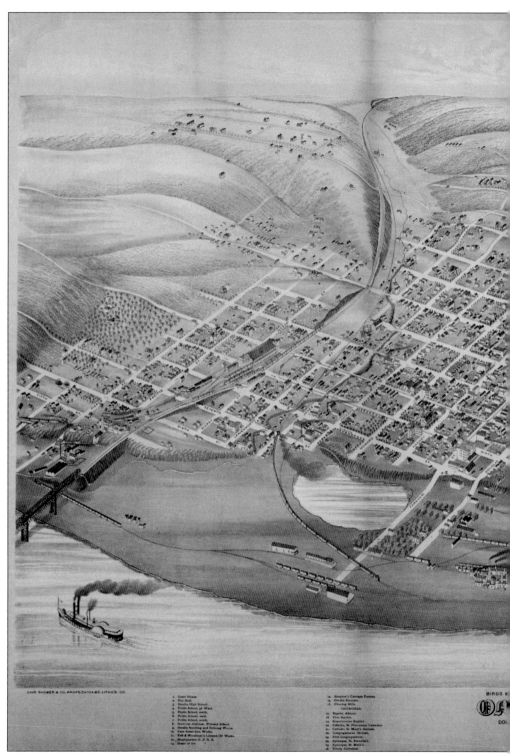

This 1876 map of Omaha shows notable growth in both the city and its churches from 12 years earlier. The legend at the bottom of the map names 22 churches, including some, such as the

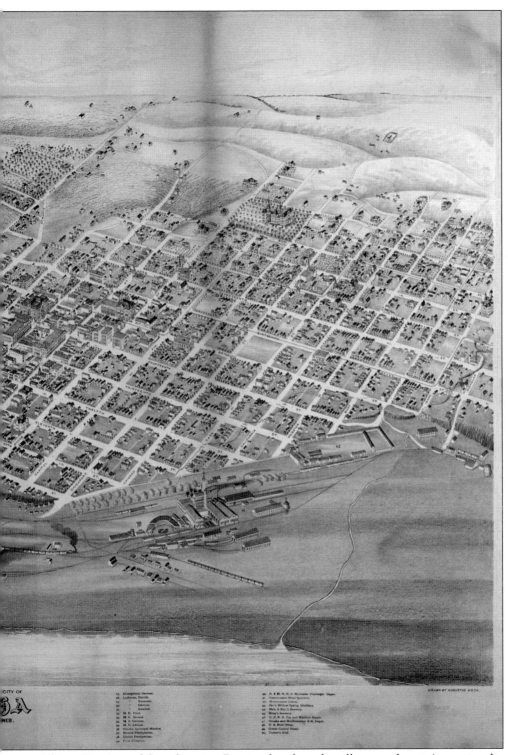

African Baptist and Scandinavian Baptist churches, that illustrate the city's growing diversity. (Courtesy of the Omaha Public Library.)

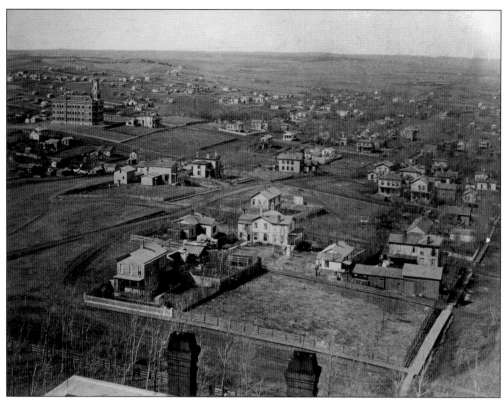

On September 7, 1878, the Jesuits opened Creighton College at its current location, at Twenty-fourth and California Streets, using a $100,000 bequest from Mary Lucretia Creighton honoring her late husband Edward, a noted business leader who helped build the transcontinental telegraph and was involved in banking. Bishop James O'Connor persuaded the Jesuits to come to Omaha to open the school. This photograph shows Creighton, which was then just one building on the hill, looking northwest from Omaha High School, today's Central High School. (Courtesy of the Omaha Public Library.)

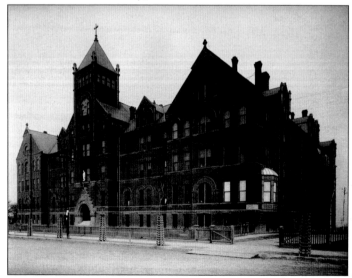

The Sisters of Mercy opened St. Joseph Hospital, Omaha's first hospital, in 1870. It was located at Tenth and Castelar Streets on lots donated by the Creighton family. John A. Creighton established the John A. Creighton Medical College and funded the hospital in 1892. (Courtesy of the Omaha Public Library.)

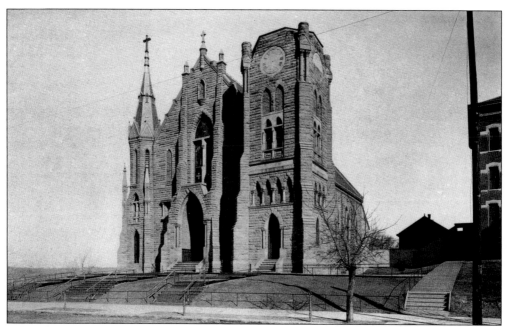

St. John's Church, on the Creighton campus, was, for the most part, built in 1887–1888. It began as a collegiate church serving students, but Bishop Richard Scannell turned it into a parish church that also served people in the area. Scannell was concerned that St. John's was drawing parishioners from other neighborhood parishes and failing to support them. (Courtesy of the Omaha Public Library.)

P.J. Creedon was the architect who drew up the original construction plans for the building in the 1880s, but he did not live to see his work fully realized. The transept and apse were not completed until the 1920s. The steeple was added in 1977. This interior photograph dates between 1890 and 1910 and shows the painted ceiling. (Courtesy of Creighton University.)

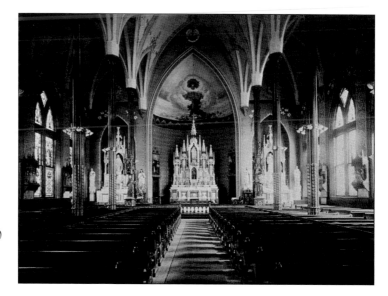

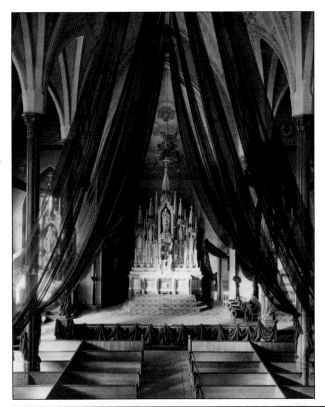

At left, the interior of St. John's Church was draped in black for the funeral of John Creighton in 1907. The photograph below shows his casket being carried out of St. John's to the waiting hearse. Creighton honors both Edward and John Creighton, and their wives, Mary Lucretia and Sarah, as its founders. (Both courtesy of Creighton University.)

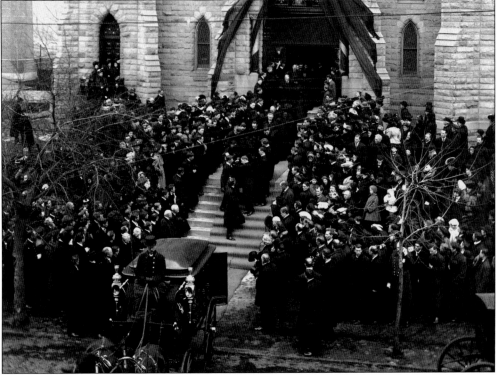

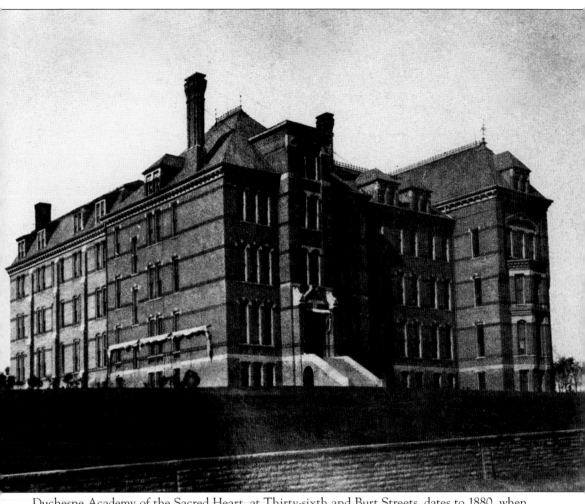

Duchesne Academy of the Sacred Heart, at Thirty-sixth and Burt Streets, dates to 1880, when Bishop James O'Connor purchased land and persuaded the Religious of the Sacred Heart to build a school for young women. The Sisters were reluctant, viewing Omaha as an underdeveloped frontier city. O'Connor reminded the sisters that the 12-acre site he had purchased was within a mile of Creighton College, so the Jesuits of Creighton could provide spiritual guidance. He also knew the school would attract wealthy Omahans to the area. (Courtesy of the Omaha Public Library.)

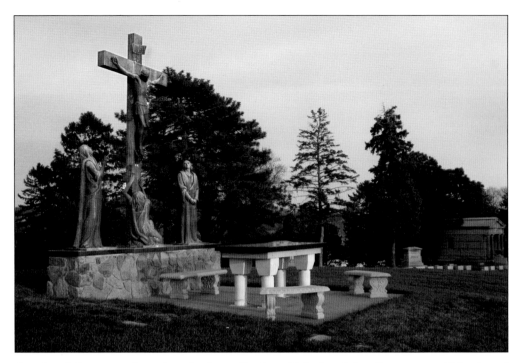

Creighton's Jesuits are buried in the Jesuit Circle at Holy Sepulchre Cemetery, at Fiftieth and Leavenworth Streets, shown here. The recessed stones in the grass mark the graves of each Jesuit, as the photograph below shows. Names are in Latin, similar to this stone marking the grave of Carl Reinert, Creighton's most important modern president. Reinert built much of today's campus, and the university library is named after him. (Both photographs by Carol McCabe.)

Two

"First" Churches and Cathedrals

By 1870, Omaha had been transformed from a struggling, muddy village to a prosperous town of about 16,000 served by about 40 churches. Some reflected the city's growing ethnic diversity in their names—German, Swedish, or African, for example. The city had become the headquarters of Union Pacific Railroad and had begun to stake its claim to regional economic dominance, pulling ahead of such former rivals as Nebraska City, despite the loss of the state capitol to Lincoln. By 1880, Omaha's population had nearly doubled to more than 30,000 served by more than 70 religious congregations including Temple Israel, its first Jewish congregation. Then came the 1880s, when Omaha's population more than quadrupled to 140,452 served by nearly 200 congregations of many faiths.

These were heady economic times in Omaha, reflecting the explosive growth of railroading, meatpacking, banking, retail, and construction. Immigrants of many nationalities flowed into Omaha to fill the thousands of jobs in railroading, the packinghouses, and other industries. New neighborhoods sprang up, including streets of mansions in the Gold Coast reflecting the city's prosperity.

No wonder Omaha religious leaders like Episcopal bishop Robert Clarkson and Catholic bishop James O'Connor dreamed of building new cathedrals. A cathedral, the principal church of a bishop's diocese, speaks to ecclesiastical power and regional religious preeminence, paralleling Omaha's status as Nebraska's dominant city. Clarkson overcame some concerns over power issues when his diocese built the new Trinity Cathedral to replace the old Trinity Episcopal Church in downtown Omaha.

O'Connor saw that Omaha would need to replace the downtown St. Philomena's Cathedral with a much larger cathedral located farther west to serve the rapidly growing Catholic population. His successor, Bishop Richard Scannell, dreamed of a truly grand cathedral that would endure for generations. In 1901, he hired noted architect Thomas Rogers Kimball to design St. Cecilia's Cathedral at the top of a hill near 40th and Cuming Streets, then the city's western edge. Scannell's dream became reality. Today's St. Cecilia's towers over the skyline, a tribute to his vision and that of the city during an unforgettable era.

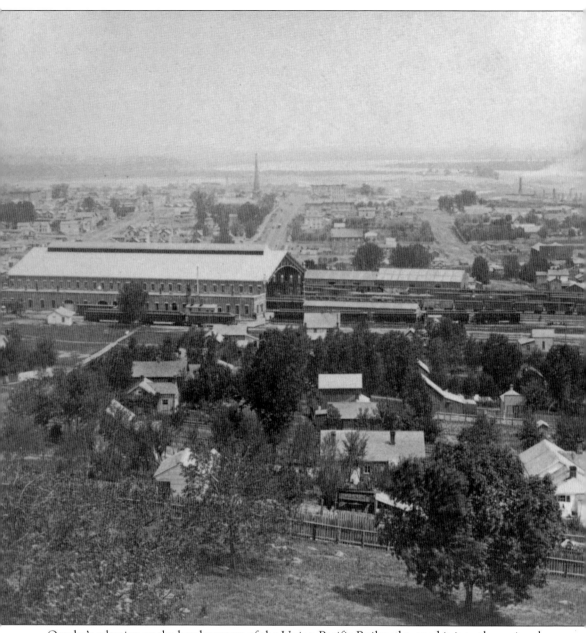

Omaha's selection as the headquarters of the Union Pacific Railroad turned it into the regional economic center. This photograph shows the original, open-ended terminal building of Union Pacific in 1880. (Courtesy of the Omaha Public Library.)

Omaha's explosive population growth in the 1880s led to a boom in housing, as illustrated by this photograph taken from the Omaha High School tower looking southeast in 1882. The cityscape contains the steeples of the nearly 100 churches serving the city by that time. (Courtesy of the Omaha Public Library.)

Omaha became a retail center with impressive stores and local companies such as the Nebraska Clothing Company (left foreground) that endured for decades. This 1898 photograph shows the growth of downtown Omaha looking south on Fourteenth Street at Farnam Street in 1898. (Courtesy of the Omaha Public Library.)

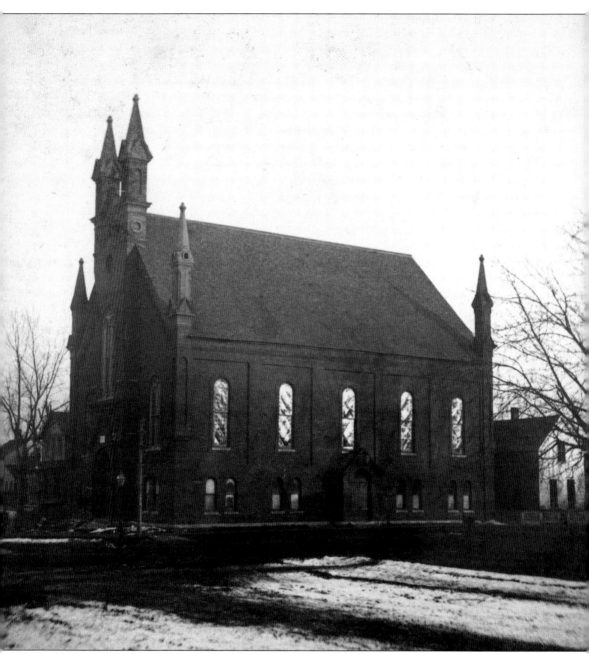

Omaha's First Baptist congregation was organized in 1855. Its first church was a small wood-frame building at Fifteenth and Douglas Streets. However, it disbanded and sold its property due to debt. The congregation built a new church at Fifteenth and Davenport Streets, shown here. The Sunday school rooms in the basement were constructed first, and services were held there until the upper floor was completed in 1881. The total value of the property was $43,000. (Courtesy of the Omaha Public Library.)

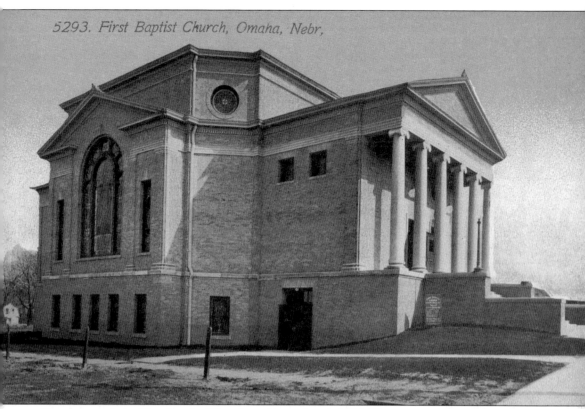

5293. First Baptist Church, Omaha, Nebr,

Fire destroyed the First Baptist Church on December 4, 1894. The society then purchased two lots on the northeast corner of Thirty-fifth and Farnam Streets. First Baptist occupied this site until the consolidation of First Baptist and Beth-Eden Baptist Churches on October 25, 1899. This shows the current church, at Twenty-seventh Street and Park Avenue, built in 1904. It is one of several Omaha "first churches" dating to this era. (Courtesy of the Omaha Public Library.)

In 1888, First Congregational Church moved to this much larger building at Nineteenth and Davenport Streets. It served the congregation until 1920. First Congregational was considered one of the most inspirational churches because of its pleasant exterior. It cost $60,000 to build. This building served the congregation until it was sold in 1920 to the Labor Temple of Omaha. It was razed in 1954 to make room for the City Auditorium. (Courtesy of the Omaha Public Library.)

This photograph shows Miss Wheatley's Sunday school class at First Congregational's Nineteenth and Davenport location about 1893. (Courtesy of First Congregational Church.)

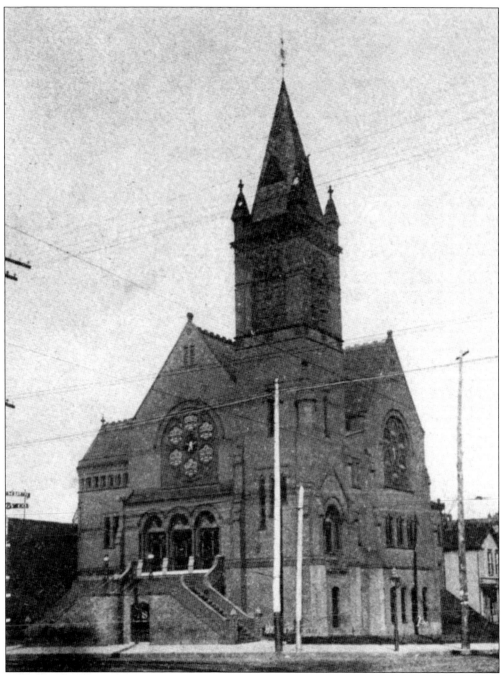

Emmanuel Evangelical Lutheran changed its name to Kountze Memorial Evangelical Lutheran Church in 1883. In 1885, it moved to this $50,000 building on the northeast corner of Sixteenth and Harney Streets. However, due to financial hardship, the congregation never officially dedicated the building. (Courtesy of the Omaha Public Library.)

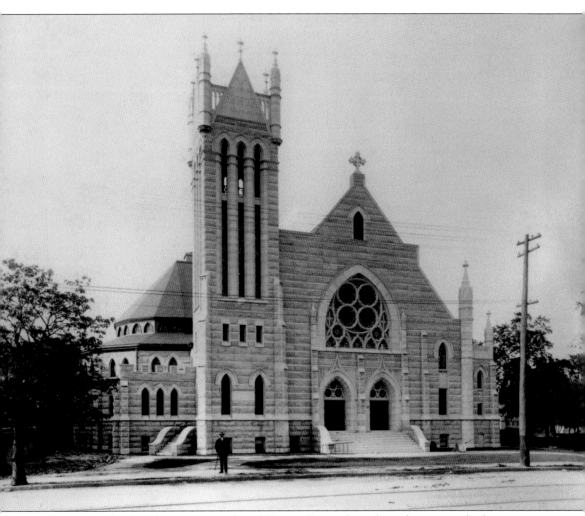

Kountze sold its building at Sixteenth and Harney Streets but salvaged portions of it for use in its third and current church building, at Twenty-sixth and Farnam Streets. It opened this building in 1906, with Kountze family members contributing nearly one-fourth of the $124,000 construction and land costs. (Courtesy of the Omaha Public Library.)

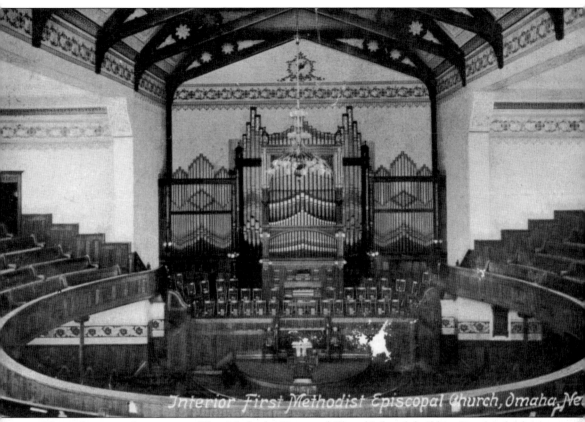

Interior First Methodist Episcopal Church, Omaha, Ne

This is the original sanctuary of First Methodist Episcopal Church's fourth building. First Methodist Episcopal is the predecessor of today's First United Methodist Church, at Seventieth and Cass Streets. The earlier three churches were at Thirteenth and Douglas Streets, Seventeenth Street and Capitol Avenue, and Seventeenth and Davenport Streets, respectively. (Courtesy of the Omaha Public Library.)

The Unitarian Church was the eighth religious institution to found a church in Omaha. A group of 26 prominent Omahans signed articles of incorporation on August 22, 1869. A site was purchased on the southeast corner of Seventeenth and Cass Streets. The property was known as Redick's Grove and was owned by the John I. Redick family. The brick, Gothic-style chapel, designed by Omaha architects John and Alan McDonald, was dedicated on January 29, 1871. A Romanesque-style addition to the chapel was built in 1891. (Courtesy of the Omaha Public Library.)

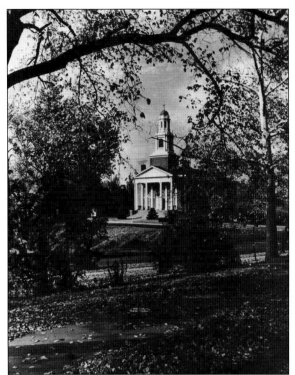

First Unitarian Church is a Colonial Revival building at Thirty-first and Harney Streets that is listed in the National Register of Historic Places. Former president William Howard Taft, who was then president of the Unitarian Church Conference in the United States and Canada, presided at the 1917 cornerstone-laying ceremony. The photograph below shows the pulpit. (Both courtesy of First Unitarian Church.)

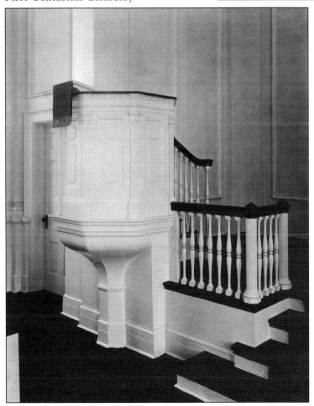

In 1891, the Presbyterians founded a theological seminary, shown here, which eventually became the Municipal University of Omaha. In 1968, Omaha University merged with the University of Nebraska and became the University of Nebraska at Omaha. (Courtesy of the Omaha Public Library.)

The Swedish Mission movement was founded in the 1880s in Sweden. Dissenters from the state-run Lutheran Church formed their own church. Members of this society arrived in Omaha in the late 1880s. The Swedish Mission Church shown here was located on the northeast corner of Twenty-third and Davenport Streets. The lot was purchased on May 11, 1887, for $11,800, and the building was completed in 1888. The church was renamed First Covenant Church of Omaha in 1927. (Courtesy of the Omaha Public Library.)

Today's Trinity Episcopal Cathedral might have remained just a parish church except for the strong leadership of Bishop Robert Clarkson, shown here. Clarkson pushed Nebraska Episcopalians to adopt a cathedral system, designating Trinity as mother church for a growing diocese. Some objected that cathedrals were too Roman Catholic for an Episcopal church, which was Protestant. (Courtesy of Clarkson College.)

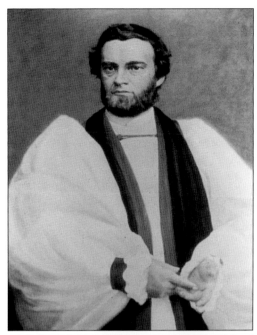

Construction of Trinity Cathedral began in 1880 at Eighteenth Street and Capitol Avenue. It was consecrated in 1883, when only the bell tower remained to be finished. Mrs. W.B. Ogden, whose husband had been the first president of the Union Pacific Railroad, donated the bells for the tower a year later. This early photograph shows the cathedral in an unknown year. (Courtesy of Trinity Episcopal Cathedral.)

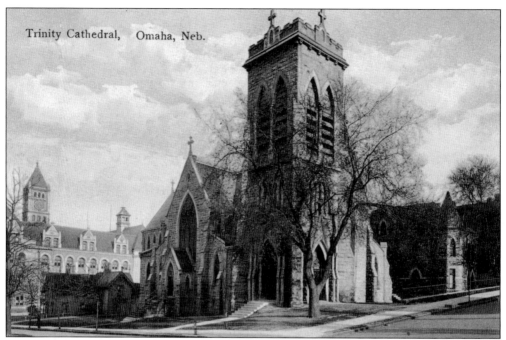

Trinity Cathedral, Omaha, Neb.

When Trinity was dedicated, Omaha historian Alfred Sorenson described the gray stone structure as "one of the handsomest church edifices in the west." The dedication was a major civic event. In an *Omaha Bee* column, Sorenson noted that a "prominent member" of the English Lutheran Church boasted that, unlike Trinity, his new church would feature an "opera house plan" in which all seats would have a good view of the "audience and stage." (Courtesy of the Omaha Public Library.)

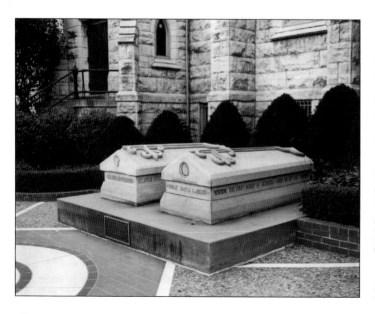

Bishop Clarkson and his wife, Meliora McPherson Clarkson, are buried in the courtyard of Trinity Cathedral. Clarkson founded 50 churches and undertook the first Episcopal mission to the Ponca Indians. He and his wife helped found Clarkson Memorial Hospital, now part of the University of Nebraska Medical Center. Clarkson College is named in his honor. (Courtesy of Trinity Episcopal Cathedral.)

Trinity Cathedral is an example of late Gothic Revival architecture, with rock-faced masonry walls and stone tracery over its stained-glass lancet windows. The church is almost entirely of bluestone from Illinois, and its design is nearly cruciform, with an entry tower extending outward. The exterior of the building has more than six stone crosses at varying points of its roofline. (Courtesy of Trinity Episcopal Cathedral.)

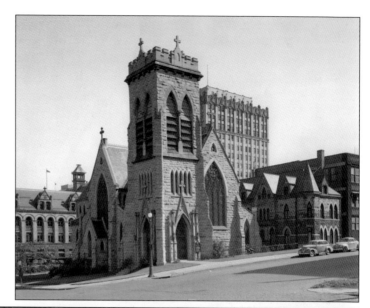

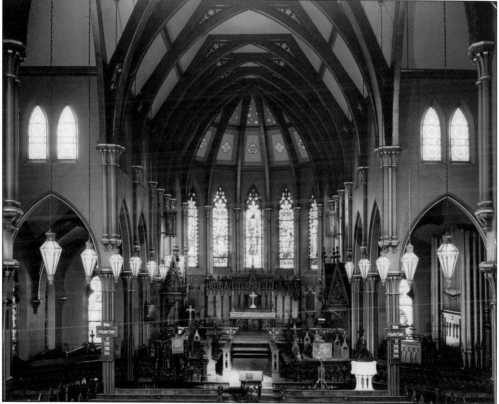

The cathedral's interior features Gothic design throughout, including the aisles, the nave, the transept, the choir, and a clerestory. It contains a noted carved-oak bishop's throne and dean's stall. Trinity seats only about 650 worshippers, leading to the consecration of some Episcopal bishops at the much larger St. Cecilia's Roman Catholic Cathedral, to allow more participants to see the ceremonies. (Courtesy of Trinity Episcopal Cathedral.)

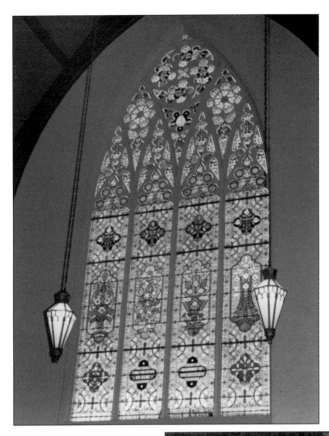

When Trinity was completed, the building, its fixtures, and the land it sat on were estimated to be worth $100,000. The cathedral is especially noted for its 43 beautiful Tiffany glass windows. (Courtesy of Trinity Episcopal Cathedral.)

Bishop James O'Connor dreamed of a new cathedral at Twenty-eighth and Leavenworth Streets to replace Omaha's second Catholic cathedral, St. Philomena's, at Ninth and Harney Streets. He knew Omaha would grow west and assumed his proposed site would be the center of Omaha. However, he died in 1890 before any work on a new cathedral could be done. (Courtesy of St. Cecilia's Cathedral.)

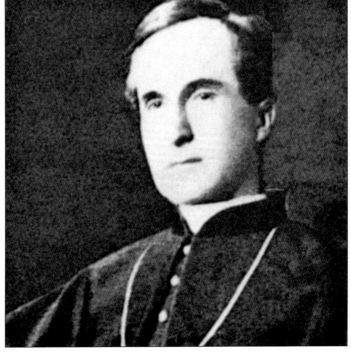

Omaha's new bishop, Richard Scannell, abandoned O'Connor's proposed location for a cathedral, announcing in 1901 that St. Cecilia's Parish "way out in the Walnut Hill area would become the new cathedral parish when a proper building could be constructed" near Fortieth and Cuming Streets. (Courtesy of St. Cecilia's Cathedral.)

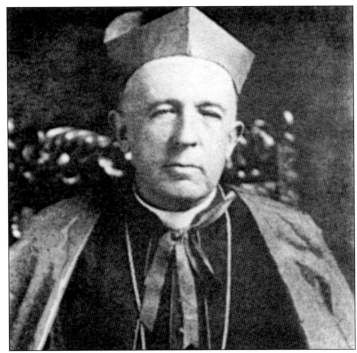

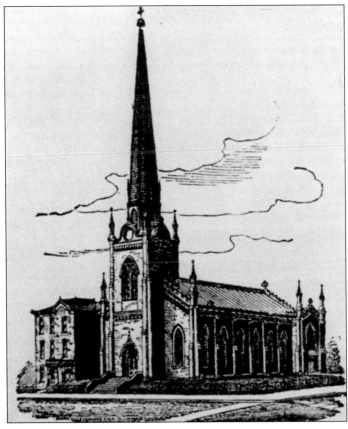

St. Philomena's Cathedral, at Ninth and Harney Streets, shown here, was dedicated in 1868 and boasted a fine marble altar from Italy. After plans for a new cathedral were developed, it was torn down in 1907. (Courtesy of St. Cecilia's Cathedral.)

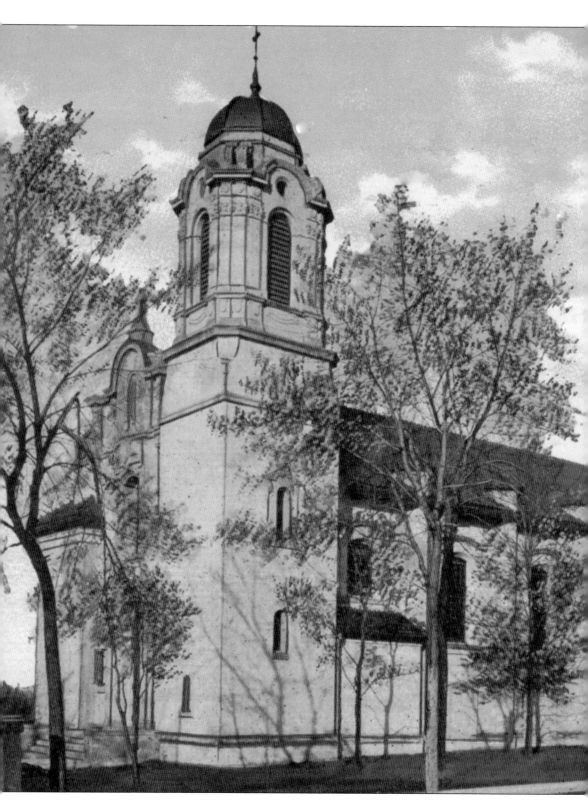

Philomena Catholic Church, Omaha, Neb.

St. Philomena's Parish opened its new church, which replaced the old cathedral in 1908. The Spanish Renaissance Revival–style building, at Tenth and William Streets, was designed by architect Thomas Rogers Kimball. The new church held cathedral status until 1916, when St. Cecilia's opened. It was renamed St. Frances Cabrini in 1958 after the nullification of St. Philomena's canonization due to doubt about her existence. (Courtesy of the Omaha Public Library.)

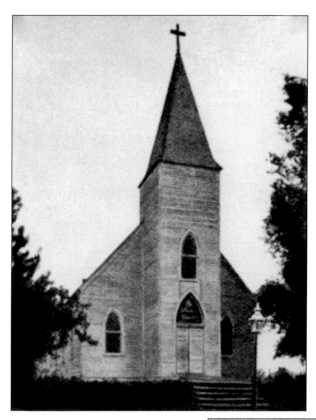

When Bishop Scannell selected St. Cecilia's Parish as the home of Omaha's new cathedral, many were surprised. The existing St. Cecilia's Church, at 4117 Hamilton Street, was a modest 40-foot-by-60-foot wood-frame building dedicated in 1888. It was so far to the west of Omaha that Mass was only held once a month. However, Bishop Scannell said that building a cathedral on the Fortieth Street hill would give the new building a commanding position overlooking the city. (Courtesy of St. Cecilia's Cathedral.)

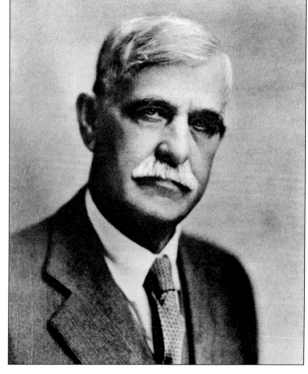

To design the new cathedral, Bishop Scannell again chose Thomas Rodgers Kimball, Omaha's most prominent architect. Kimball served as president of the American Institute of Architects and, with his partner, was architect in chief of Omaha's Trans-Mississippi and International Exposition in 1898. He designed many other noted Omaha buildings, such as the Fontenelle Hotel. (Courtesy of St. Cecilia's Cathedral.)

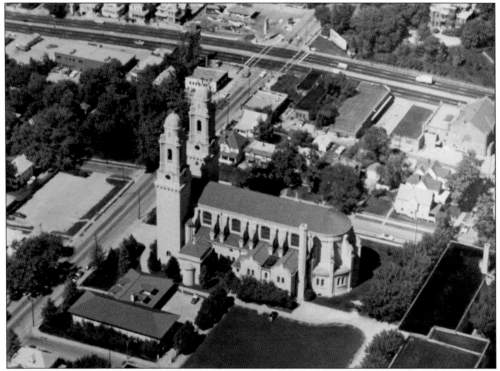

Today's magnificent St. Cecilia's Cathedral is such an Omaha landmark that it is hard to believe that constructing the building near Fortieth and Burt Streets was so controversial that no groundbreaking was held when excavation began on May 12, 1905. Kimball again chose a Spanish Renaissance style in honor of the Spanish missionaries to the west. In the 18th century, Nebraska was home to a mission of a Spanish diocese in Cuba. (Courtesy of St. Cecilia's Cathedral.)

By the time construction started on St. Cecilia's, the neighborhood in which it was located enjoyed a reputation as an exclusive district. Today, homes such as these, in the 300 block of South Thirty-seventh Street, are part of the Gold Coast Historic District, which is listed in the National Register of Historic Places. (Courtesy of St. Cecilia's Cathedral.)

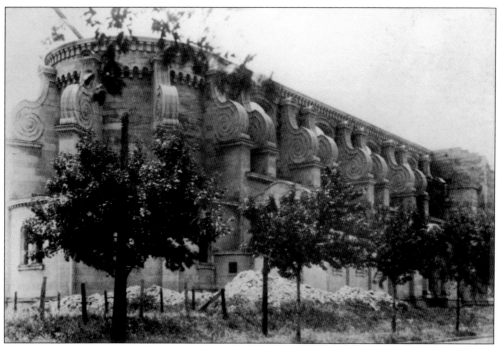

St. Cecilia's is ranked as one of the nation's 10 largest cathedrals and is listed in the National Register of Historic Places. The limestone structure measures 250 feet by 158 feet. About 100 tons of steel support the roof and the floor. There are one million pounds of concrete in the foundation and over three million bricks in the structure. (Courtesy of St. Cecilia's Cathedral.)

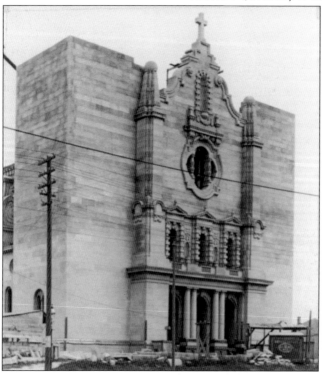

One reason it took so long to build the cathedral was that church leaders paid for construction as money was available. The church borrowed money for the first time in 1917 after a windstorm damaged part of the roof and stifled progress. Work halted during the Depression, and it took intensive fundraising drives in the 1940s and 1950s to finish the cathedral. (Courtesy of St. Cecilia's Cathedral.)

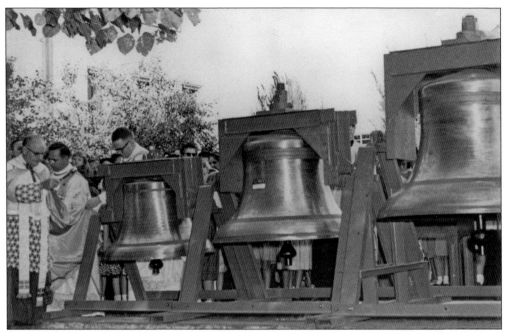

Edward C. Epsen donated the massive bells of St. Cecilia's Cathedral in memory of his late son and daughter-in-law, Mr. and Mrs. Edward J. Epsen. Here, cathedral pastor Msgr. Ernest Graham consecrates the bells, which are now electronically controlled. The bells are named for St. Edward, St. Helen, and Our Lady of Lourdes. (Courtesy of St. Cecilia's Cathedral.)

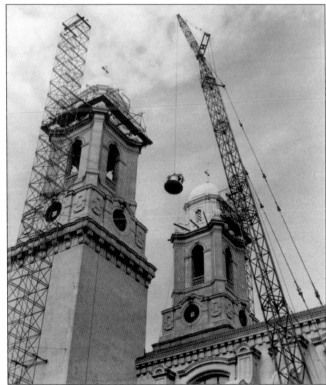

Two of the most notable features of St. Cecilia's are its two 197-foot towers. This photograph shows the towers nearing completion. They were finished in 1958, more than 50 years after the building's cornerstone was laid. (Courtesy of St. Cecilia's Cathedral.)

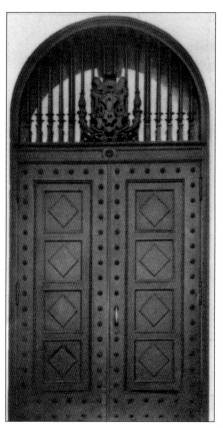

The experience of visiting the cathedral begins with opening one of its eight great bronze doors, which were cast from original designs by Kimball. The doors are marked by an absence of low relief work and by grillwork above. (Courtesy of St. Cecilia's Cathedral.)

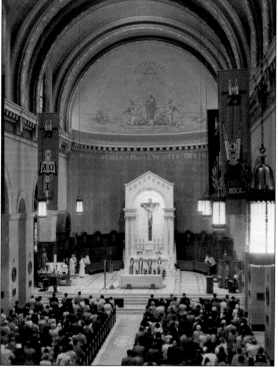

The plan of the cathedral nave is a series of five great bays, with each bay composed of four enclosing arches that support the pendentives of the ceiling dome. Transverse barred vaults that follow the semicircle of the huge arches spanning the nave link the bays. (Courtesy of St. Cecilia's Cathedral.)

The focal point of the sanctuary is the high altar of white Carrara marble that Kimball designed. It was built in Pietrasanta, Italy, shipped to America duty-free, and transported to Omaha in sections. Since Vatican II in the 1960s, Mass has been said from a wooden altar facing the congregation. (Courtesy of St. Cecilia's Cathedral.)

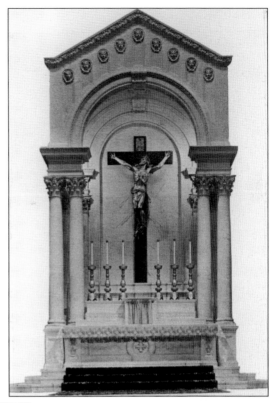

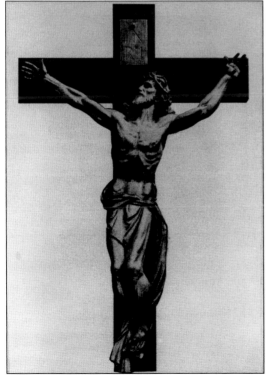

The bronze crucifix, created by sculptor Albin Polasek, is 13 feet high and six feet wide. It shows Christ looking up facing heaven and praying, "Father forgive them for they know not what they do." This is an extraordinary depiction of Christ on the cross. (Courtesy of St. Cecilia's Cathedral.)

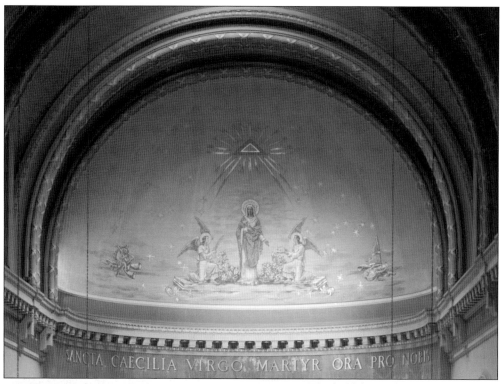

SANCTA CAECILIA VIRGO MARTYR ORA PRO NOBIS

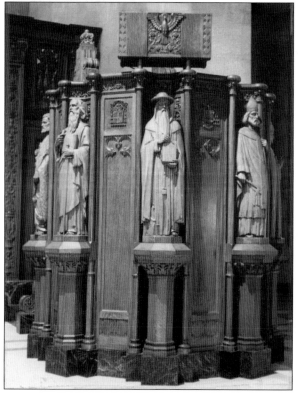

The half dome above the main altar depicts the cathedral's patron saint, St. Cecilia, with symbols of her virginity, martyrdom, and heavenly glory. St. Cecilia was the daughter of an aristocratic Roman family who was martyred for refusing to acknowledge pagan gods. She is the patroness of music of the Roman Catholic Church, as well as patroness of the Archdiocese of Omaha. (Courtesy of St. Cecilia's Cathedral.)

On the right in the sanctuary is the pulpit that Kimball designed. It features South American mahogany statues of six great doctors of the church: St. Peter, St. Paul, St. Jerome, St. Ambrose, St. Pope Gregory the Great, and St. Augustine. Albin Polasek carved the statues. (Courtesy of St. Cecilia's Cathedral.)

The sanctuary is noted for its oak wood carvings, including whimsical heads in the foliated designs of the stiles, shown at right in one of the detailed panels. Enshrined in the niches along the wall are 11 of Christ's apostles, as seen below. The statues were created and designed by Polasek, but sculptor William Hoppe completed some after Polasek suffered a stroke. (Both courtesy of St. Cecilia's Cathedral.)

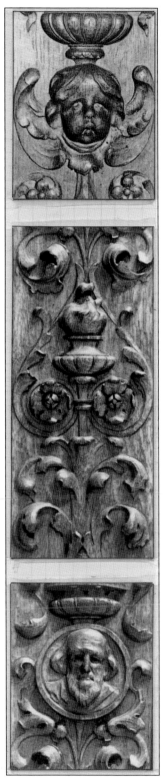

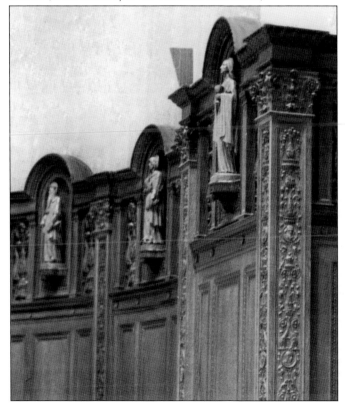

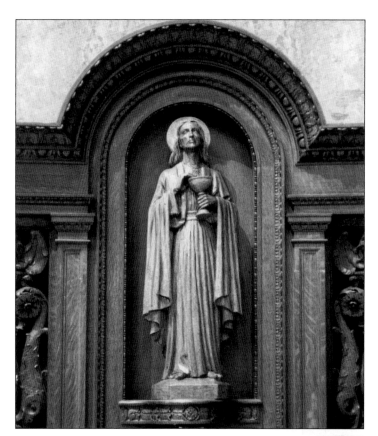

Before his stroke, Polasek carved statues of the Apostles John (shown here), Andrew, Thomas, Bartholomew, and Matthew. (Courtesy of St. Cecilia's Cathedral.)

The Cathedral's primary artist, Albin Polasek, designed the 14 bronze relief Stations of the Cross. He first sculpted them in clay before casting them in bronze. They are hung on the pillars of the nave. In this image of the 12th station, Jesus dies on the cross. Polasek included a self-portrait as the figure in the lower right. (Courtesy of St. Cecilia's Cathedral.)

St. Cecilia's includes more than 50 stained-glass windows, with much of the glass imported from England and Scotland. Lighting the nave on each side are eight "singing windows" in honor of St. Cecilia, the patron saint of music. They were created by Charles Connock of Boston and depict great liturgical hymns such as this one honoring Mary's Magnificat. It depicts her visit to St. Elizabeth and praises God for her part in the incarnation of Christ. (Courtesy of St. Cecilia's Cathedral.)

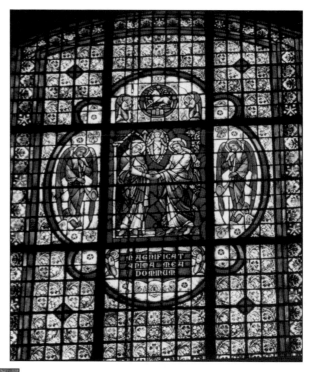

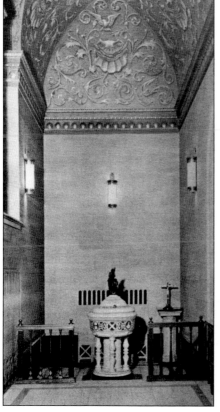

The cathedral's baptistery is on the church's north side and can be viewed through bronze balusters. It is sunk two steps below floor level. Light from two stained-glass windows glints on the bronze figures of John the Baptist, with the young Christ on the front cover of the baptismal font. (Courtesy of St. Cecilia's Cathedral.)

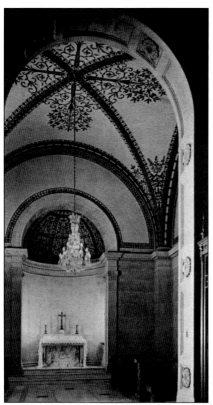

The Nash Chapel, on the south side of the cathedral, honors the family of Edward Nash, an early Omaha community leader who helped finance the building of St. Cecilia's. The chapel serves as a private mortuary chapel for members of the Nash family. The ceiling is encrusted with a black-and-gold mosaic. The antique crystal chandelier is from the Nash home. The chapel is noted for the rosy light that glows from the ruby stained-glass windows. (Courtesy of St. Cecilia's Cathedral.)

This photograph shows the residence of Edward W. Nash. He was a major benefactor of St. Cecilia's Cathedral and is buried in its Nash Chapel. (Courtesy of St. Cecilia's Cathedral.)

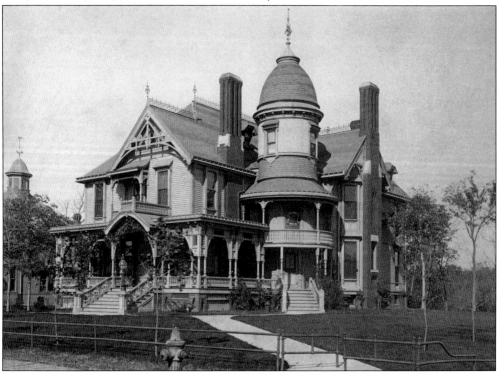

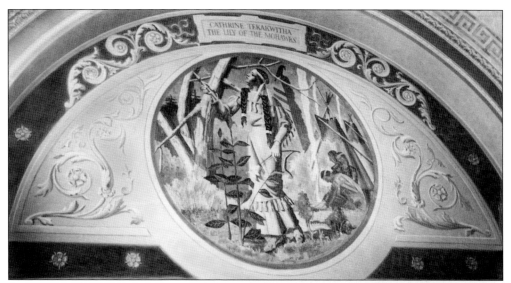

CATHRINE TEKAKWITHA
THE LILY OF THE MOHAWKS

St. Cecilia's celebrates new-world spiritual heroes such as St. Kateri Tekakwitha, a North American Indian who converted to Christianity and suffered mistreatment for her faith. At one point, she was stoned for refusing to work on Sunday. She died in 1680. This mural is above the entrance of Our Lady of Nebraska Chapel. (Courtesy of St. Cecilia's Cathedral.)

This statue of Madonna of Corn is a focus of the Our Lady of Nebraska Chapel, inside the north entrance. The statue was carved from Carrara marble by Arthur Lorenzani of New York from a plaster model by Polasek. In it, the Blessed Virgin holds a stalk of corn to symbolize her concern for the people of Nebraska. (Courtesy of St. Cecilia's Cathedral.)

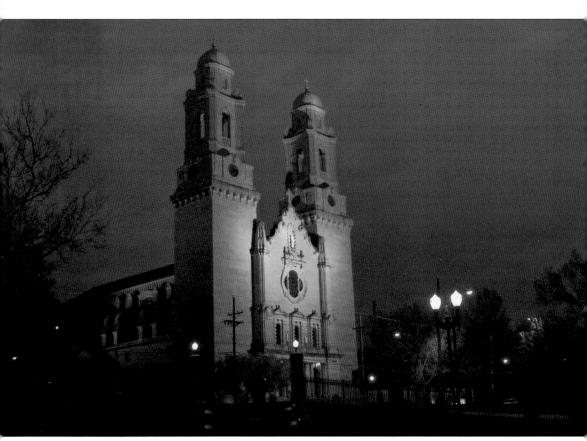

This dramatic night shot of St. Cecilia's shows the cathedral, which is lighted every evening and can be seen from distant parts of the city because of its height and location on top of the hill. (Photograph by Carol McCabe.)

Three

CHURCHES SERVING OMAHA'S ETHNIC COMMUNITIES

Jews came to Omaha from Russia seeking freedom from religious persecution, while Danes sought relief from German military occupation of their home provinces. Irish came to help build the Union Pacific Railroad, and a Czech newspaper that *Omaha Bee* publisher Edward Rosewater circulated in Austria-Hungary drew many Bohemians to the city.

Whatever their reason, a rich mixture of Italians from Sicily, Poles, Germans, Croats, Slavs, African Americans, Magyars, Greeks, Syrians, and others settled in Omaha between 1880 and 1910. The census of 1910 found that 22 percent of the city's people were foreign-born, a higher percentage than the national average, but not everyone was impressed. British author Rudyard Kipling, who passed through Omaha in 1889, showed his prejudice by claiming that it was populated mainly by foreigners, including "all the scum of the Eastern European states."

Although immigrants settled in ethnic neighborhoods throughout Omaha, South Omaha City (then a separate town) was a magnet because its packinghouses needed an endless supply of workers. Railroads and other industries also provided opportunities to newcomers seeking a better life, including African Americans from the South.

Residents called South Omaha "Magic City" because of its robust economy, although its odor seemed scarcely magic to others. However, the immigrants who toiled in horrific conditions must also have yearned for beauty and spirituality, because they created their own enduring "magic" in their churches.

Churches of all persuasions in today's North and South Omaha testify to the city's rich tapestry of people and their faiths. Soon after their arrival, most groups started congregations to preserve their heritage.

Street corners in South Omaha boast lovely Orthodox churches with cupolas instead of steeples. Hebrew lettering on buildings in North Omaha is a reminder of their years as small synagogues. North Omaha's African American neighborhoods are home to many denominations, but most churches, including such historic buildings as St. John's AME Church, are Methodist or Baptist. When Mexicans arrived in South Omaha, they founded Our Lady of Guadalupe Church in 1919—an integral part of today's vibrant Hispanic community.

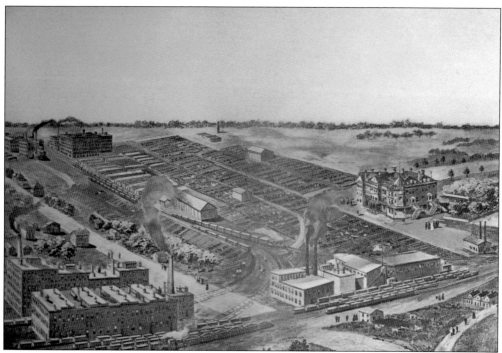

The Union Stockyards, shown here in the mid-1880s, quickly became Omaha's largest industry and a dominant image of the city. The building at upper right above is the stock exchange building. The photograph below is a close-up of this important business center. (Both courtesy of the Omaha Public Library.)

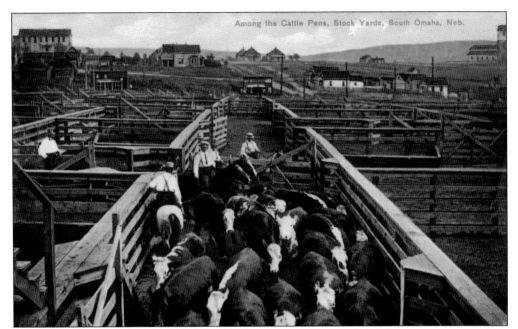

The stockyards began in 1883 when Wyoming cattle baron Alexander Swan wanted a livestock market closer than Chicago. Together with six local businessmen, he formed the Union Stockyards on December 1, 1883. The livestock pens covered acres of land. The Union Stockyards was the world's largest sheep market. The stockyards depended on the Union Pacific Railroad to bring livestock to market. (Courtesy of the Omaha Public Library.)

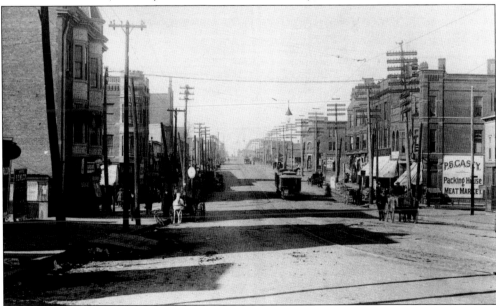

South Omaha City was founded in 1884 and grew to 8,000 people by 1890. Most of its people were immigrants from Southern and Eastern Europe who worked in the packinghouses. Omaha annexed South Omaha City in 1915, by which time it had grown to 30,000 people. This photograph shows some of the buildings on South Twenty-fourth Street, which remains the area's downtown. (Courtesy of the Omaha Public Library.)

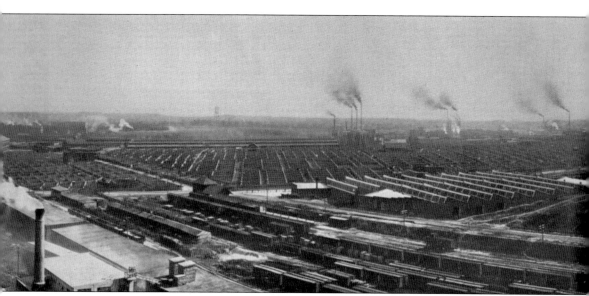

Omaha's Union Stockyards in South Omaha City fueled the area's growth by attracting thousands of immigrants from all over Europe, drawn to work in the slaughtering houses. On average, 20,000 animals per day arrived at the Union Stockyards for slaughter. The livestock pens covered acres of land. (Courtesy of the Omaha Public Library.)

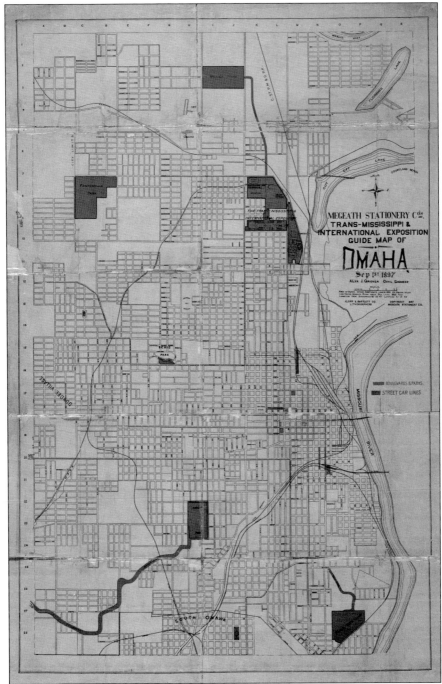

Many groups, including Jews, Irish, African Americans, Germans, and Scandinavians, settled in ethnic neighborhoods in North Omaha. This map from 1897 shows some historic landmarks, such as Prospect Hill Cemetery, where many of Omaha's noted settlers are buried. Most of North Omaha was made up of residential neighborhoods interspersed with commercial strips such as the downtowns of Florence and Benson, which Omaha annexed in 1917. (Courtesy of the Omaha Public Library.)

Omaha created the Trans-Mississippi International Exposition of 1898 to showcase the city and the products of the West. It drew 2.6 million visitors, including Pres. William McKinley. The fairgrounds were on the Missouri River between Locust Street and Ames Avenue in North Omaha. These postcards show exposition buildings. (Both courtesy of the Omaha Public Library.)

First came the Irish, making Roman Catholicism Omaha's largest denomination from pioneer days to the present. This photograph shows Omaha's first Catholic bishop, James O'Gorman, who served the new diocese from 1859 to 1874. Like his two successors, Bishops James O'Connor and Richard Scannell, O'Gorman was born in Ireland. (Courtesy of St. Cecilia's Cathedral.)

This photograph shows St. Philip the Deacon Episcopal Church, located at 1119 North Twenty-first Street. This church was reserved for black members of the Episcopal faith. The Rev. J.A. Williams was the rector of the church at the time this photograph was taken, around 1896. (Courtesy of the Omaha Public Library.)

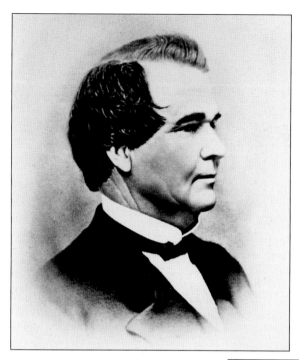

Devout Catholic business leaders like Edward Creighton helped shape their city both economically and religiously. Creighton helped build the transcontinental telegraph between Omaha and Salt Lake City in 1861 and was involved in railroading, banking, and other enterprises. He is best known for bestowing his name on Creighton University. His widow, Mary Lucretia, and his brother John donated funds from his estate to the church to endow a Catholic university. (Courtesy of Creighton University.)

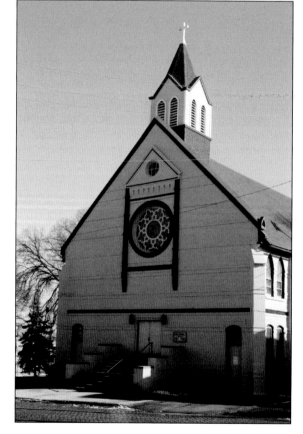

Holy Family Catholic Church, at Seventeenth and Izard Streets, was built in 1883 to serve the growing Catholic population in North Omaha, including many people who worked in the Union Pacific repair shops. The building is listed in the National Register of Historic Places. (Photograph by Carol McCabe.)

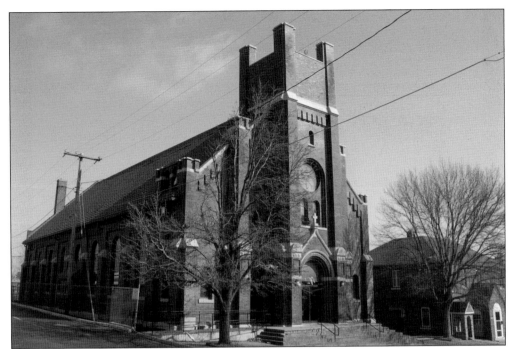

South Omaha's Irish population continued to grow during the 1880s. To serve the community, St. Patrick's Parish was organized at Fifteenth and Castelar Streets in 1883, but later moved one block east. This photograph shows the larger St. Patrick's Church that was built on that site in 1910. (Photograph by Carol McCabe.)

As the packinghouses grew, so did the number of Catholics who lived near them. New parishes that were organized to serve them included St. Agnes Church, at Twenty-third and Q Streets, and St. Bridget's Church, shown here at 4112 South Twenty-sixth Street. St. Bridget's became an independent parish in 1895. The original church burned down in 1920 and was replaced by the current building, shown here. (Photograph by Carol McCabe.)

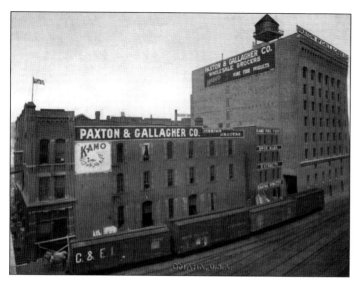

Irish business leaders such as Ben Gallagher, who formed the food wholesaler Paxton & Gallagher, were prominent in Omaha. Butternut Coffee was Paxton & Gallagher's most noted product. This photograph shows the Butternut Building, which has since burned down, on Tenth Street near today's Old Market. Gallagher's mother was an Irish-born resident of Pleasant Grove, Iowa. (Courtesy of the Omaha Public Library.)

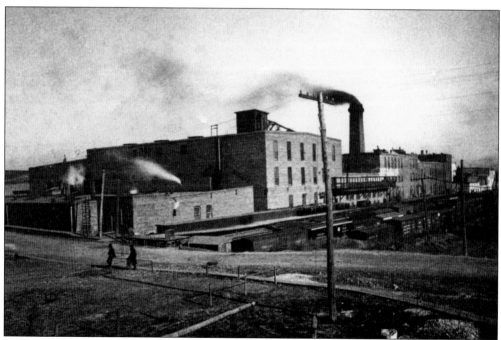

Irishmen did not just work in the packing plants; some, like Edward Cudahy Sr., ran them. Cudahy came to Omaha in the 1880s to manage the newly formed Armour-Cudahy Company and, with his brother Michael, bought the company in 1890. The Cudahy packing plant employed thousands and helped the Omaha Stockyards become a leading force in the industry. (Courtesy of the Omaha Public Library.)

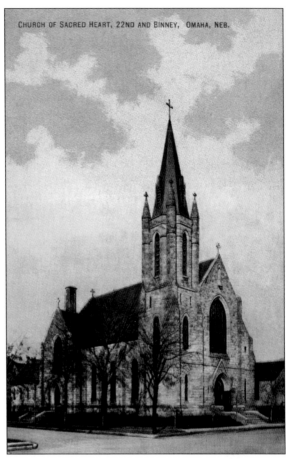

The Omaha Diocese continued to expand to serve the growing Irish population in North Omaha. In 1890, Bishop James O'Connor organized the first Sacred Heart Church, at Twenty-sixth and Sprague Streets. As the parish grew, it needed a new church, and it moved to its current location at Twenty-second and Binney Streets, where a new church was built. Construction of today's beautiful stone church began in 1900. It is noted for its 124-foot spire and late Gothic Revival architecture. At the time, many wealthy Omahans built large homes in the parish, as can be seen below. (Both courtesy of the Omaha Public Library.)

Irish politicians have long been prominent in Omaha, including the controversial Tom Dennison, who was viewed as Omaha's political boss during the early decades of the 20th century. Dennison was allegedly in charge of Omaha's crime rings, including prostitution, gambling, and bootlegging in the 1920s. He is credited with electing "Cowboy" James Dahlman as mayor eight times and controlling local politics. He was tried for conspiracy in 1934 but was acquitted and died later that year. More than 1,000 people attended his funeral at St. Peter's Catholic Church, at 2706 Leavenworth Street. (Courtesy of the Douglas County Historical Society.)

Omaha's best-known Irish Catholic was Father Edward J. Flanagan, the founder of Boys Town. He was born in Ireland and assigned to the Omaha Diocese in 1912. In 1917, he opened his first boys' home in downtown Omaha. In 1921, it moved to its current location west of Omaha. Father Flanagan became internationally known through the 1938 movie *Boys Town*, featuring Mickey Rooney and Spencer Tracey. Flanagan died in Berlin in 1948, where he was seeking to help war orphans. He has been nominated for canonization as a Catholic saint. (Courtesy of Boys Town.)

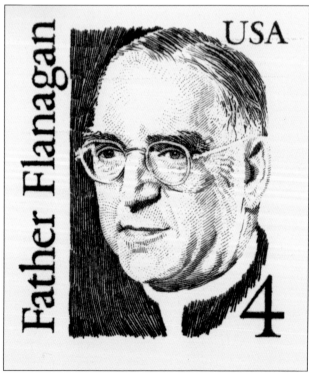

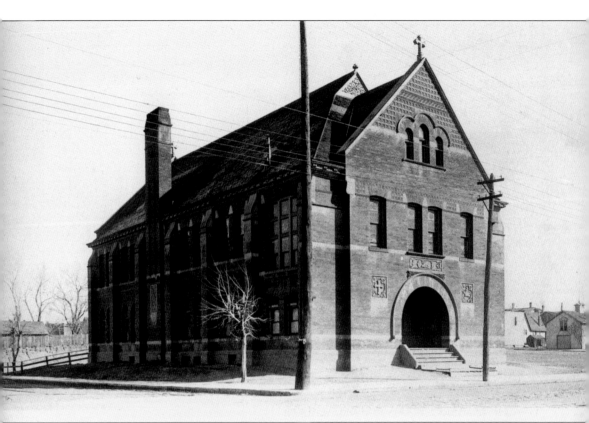

St. Peter's Church was established in 1886. Both St. Agnes' and St. Peter's were designed with identical layouts, with religious services held on the upper floor and a school on the ground floor. The cornerstone for the new St. Peter's Church, at 2706 Leavenworth Street, was laid in 1924. (Courtesy of the Omaha Public Library.)

St. Agnes' Parish was incorporated on April 17, 1886. The cornerstone of the building, shown here at 2215 Q Street, was laid on May 26, 1889, and dedicated on October 13, 1889. The structure was designed with a church on the upper floor and a school on the lower level. (Courtesy of the Omaha Public Library.)

Today's Irish Americans have lost the distinctiveness of their immigrant ancestors; they are an integral part of all aspects of Omaha life. However, symbols of their Celtic heritage, such as the window of St. Mary's Catholic Church, at Thirty-sixth and Q Streets, as well as shamrocks painted in streets on St. Patrick's Day, remind Omahans of their crucial contributions to the city's heritage. (Photograph by Carol McCabe.)

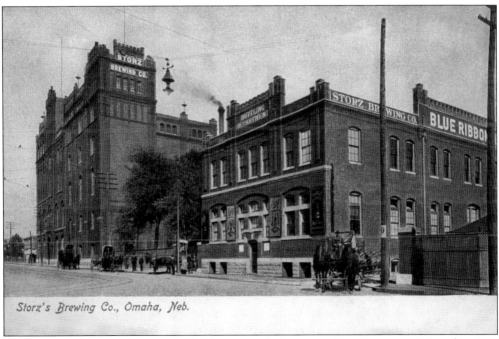

Storz's Brewing Co., Omaha, Neb.

In 1900, one-fourth of Omaha's foreign-born population came from Germany, giving the city a distinct German flavor. Omaha Germans were divided between Catholics and Lutherans, but they were united by a love for German food, beer, music, and culture. One of Omaha's most important German enterprises was Storz Brewery, at 1807 North Sixteenth Street. The brewery won medals at the 1898 Trans-Mississippi Exposition. (Courtesy of the Omaha Public Library.)

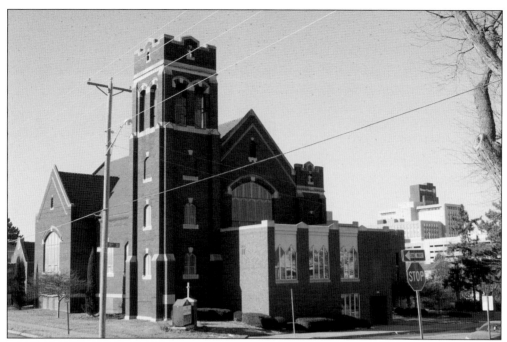

Other Lutheran churches were soon established after Kountze Memorial took root. First Lutheran Church was organized in 1873 at Eleventh and Jackson Streets. In 1883, that church building was moved to Twentieth and Mason Streets and renovated. In 1922, the congregation moved to its current location, at Thirty-first and Jackson Streets. The congregation is noted for its social ministry outreach. (Photograph by Carol McCabe.)

Cross Lutheran Church, at Twentieth and Vinton Streets in South Omaha, was organized by a pastor and many members of First Lutheran Church in 1918. This photograph shows the building today. (Photograph by Carol McCabe.)

In 1886, St. Joseph Church was organized as a parish for South Omaha's German and Polish families. In its early days, the parish struggled to serve people who spoke various languages. When Bishop Scannell persuaded the Franciscans to take charge of the parish in 1895, he allowed them to preach in English and promised that a Polish priest would serve his fellow Poles until other arrangements could be made. This photograph shows today's church, at 1723 South Seventeenth Street. (Photograph by Carol McCabe.)

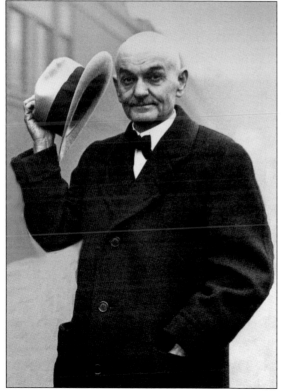

Omahans of German descent were active in business and politics, including "Cowboy" Jim Dahlman, who was born in Texas and worked as a cowboy and ranch hand in Nebraska and Wyoming before moving to Omaha in 1898. He took a job as a livestock commissioner and ran for mayor in 1906. He wowed crowds with his lariat skills and frontier tales. He served as mayor for 21 years and owed a heavy debt to political boss Tom Dennison. (Courtesy of the Douglas County Historical Society.)

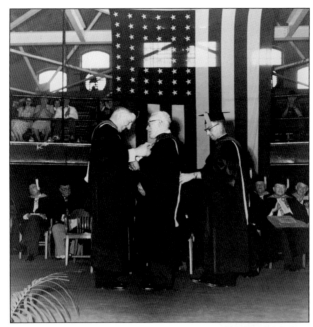

One of Omaha's most distinguished German families, the Peter family, published a German-language newspaper and now runs Interstate Printing. It was involved in a famous free speech lawsuit challenging a Nebraska law that banned teaching elementary schools in German after World War I. The family also has strong ties to Creighton and the Catholic church. At left, Valentine Peter receives an honorary degree from Creighton. His grandson Father Val Peter (below) served as the head of Boys Town for many years. (Both courtesy of Creighton University.)

German immigrant William Schmoller was a young teacher who liked to play the piano for groups, but his father in Germany disapproved of such frivolity, so he left for the United States and arrived in Omaha in 1883. His first job was playing the piano at an entertainment location. He began repairing pianos and giving piano lessons to young Omahans. He then joined Arthur C. Mueller in the piano business. Mueller operated piano stores in both Omaha and Council Bluffs. For years, Schmoller-Mueller was Omaha's leading music store, and their business illustrates the German love of music. (Courtesy of the Omaha Public Library.)

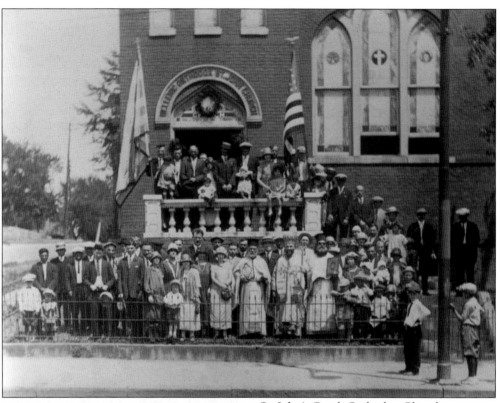

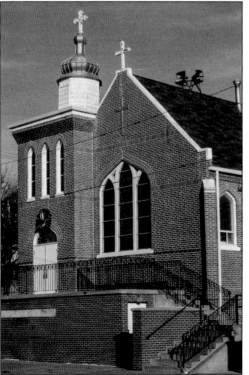

St. John's Greek Orthodox Church was founded in 1908, when there was an influx of Greeks working at the packinghouses. By 1907, most of Omaha's 2,000 Greeks were concentrated in South Omaha. This photograph shows members of the church outside of their building, at Sixteenth and Martha Streets. The photograph to the left shows the same church, which is now Assumption Ukrainian Catholic Church. (Above, courtesy of St. John's Greek Orthodox Church; left, photograph by Carol McCabe.)

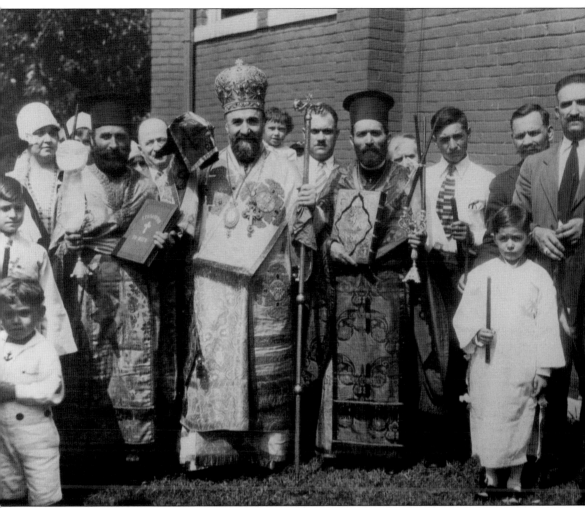

Like all Orthodox churches, St. John's is noted for its beautiful traditional liturgies and the preservation of its ancient heritage. This historical photograph shows clergy and church members in their distinctive vestments and ethnic attire. (Courtesy of St. John's Greek Orthodox Church.)

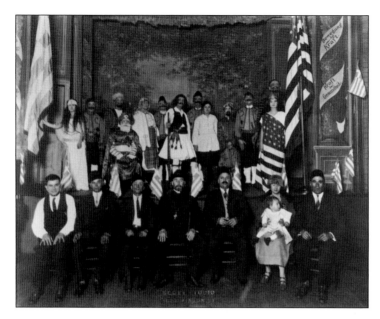

Omaha Greeks have always celebrated their heritage at plays like this one. However, in 1909, there was anti-Greek rioting in South Omaha following an accusation that a Greek who was being arrested shot a popular Irish police officer. National coverage sympathized with the Omaha Greeks, although Omahans tended to favor the police officer. (Courtesy of St. John's Greek Orthodox Church.)

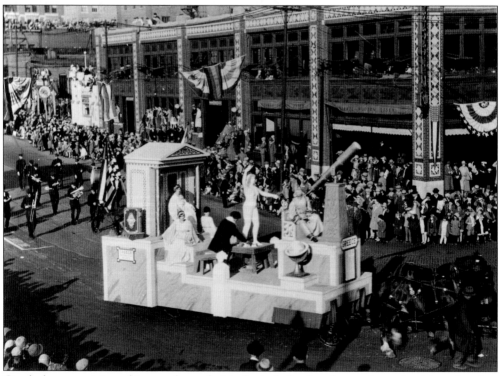

Greeks have participated in parades and civic festivals for decades, as shown by this early prize-winning float. Today, St. John's Greek Orthodox Church sponsors a popular annual Greek Festival featuring Greek food, dancing, and music, and thousands of Omahans of all backgrounds attend it. (Courtesy of St. John's Greek Orthodox Church.)

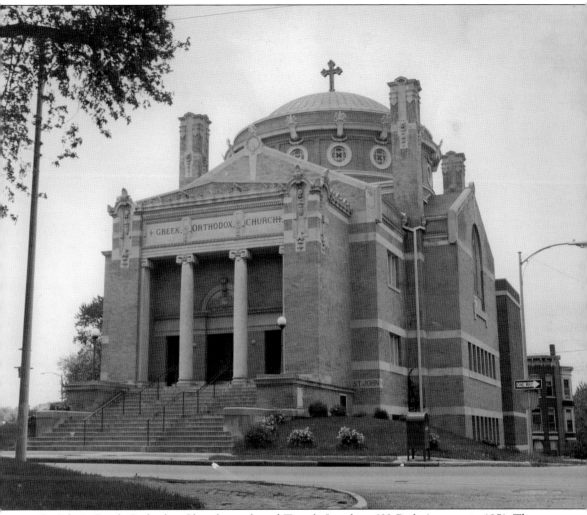

St. John's Greek Orthodox Church purchased Temple Israel, at 602 Park Avenue, in 1951. The building was designed by noted Omaha architect John Latenser Sr. and extensively renovated. Omaha's Oscar-winning film director, Alexander Payne, served as an altar boy at St. John's. (Courtesy of St. John's Greek Orthodox Church.)

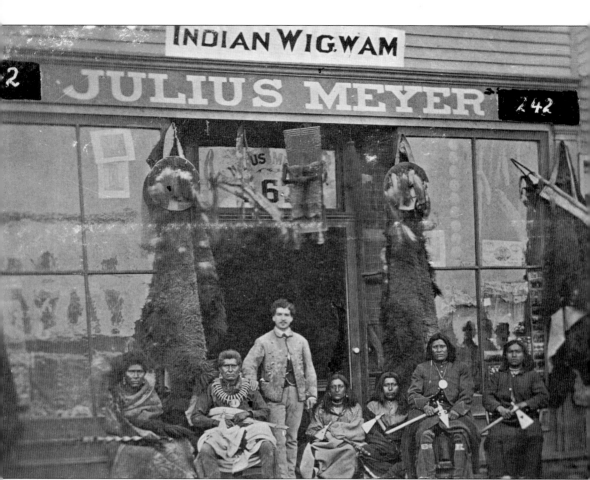

Julius Meyer was one of Omaha's first Jewish settlers. One of five brothers, he opened his Indian Wigwam in 1866 to sell Indian souvenirs, trinkets, and artifacts that he acquired while traveling around Nebraska trading for beads and hides. The Meyer brothers made sporadic attempts to start a Jewish congregation but failed due to lack of money. In the 1860s, religious services were held only on the high holy days. (Courtesy of the Omaha Public Library.)

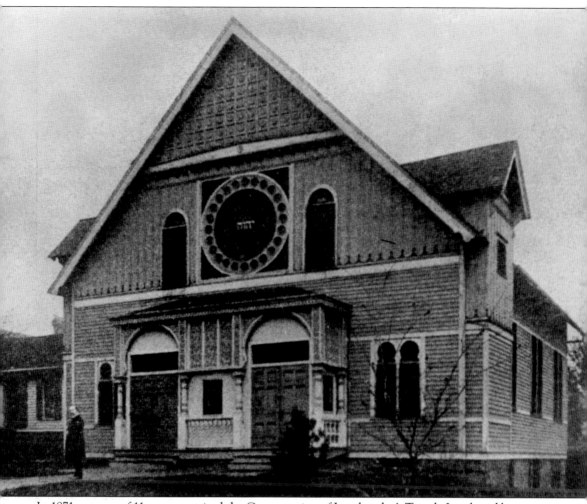

In 1871, a group of 11 men organized the Congregation of Israel, today's Temple Israel, and began searching for a rabbi. It finally acquired its first fulltime rabbi in 1878 to minister to the 20-member congregation. The temple's first building, seen here, was dedicated in 1884 at Twenty-third and Harney Streets. (Courtesy of Temple Israel.)

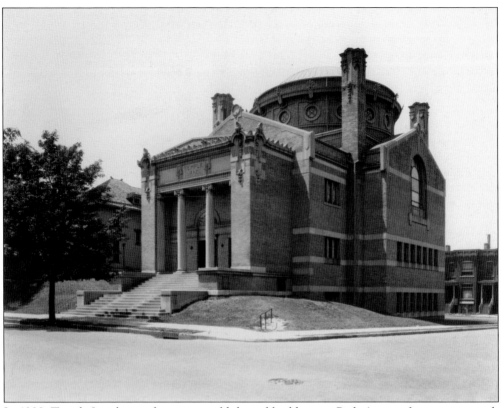

In 1908, Temple Israel moved to a new gold-domed building on Park Avenue featuring stained-glass windows depicting David playing the harp and Moses descending from Mount Sinai. Today, the building houses St. John's Greek Orthodox Church. The temple remained in this location until 1954, when it moved to a new building at Sixty-ninth and Cass Streets, shown below. (Both courtesy of Temple Israel.)

This Bible Church, at Twenty-third and J Streets, behind South High School, began as a synagogue and then became Wheeler Memorial Presbyterian Church. Omaha had many scattered synagogues before they consolidated into three main congregations: Temple Israel, Beth El Synagogue, and Beth Israel Synagogue. (Photograph by Carol McCabe.)

Golden Hill Cemetery was established in 1888 to serve the Orthodox Jewish community. This small cemetery, at 5025 North Forty-second Street, contains the graves of many Jewish soldiers killed in World War I and World War II, as well as Rose Blumkin, founder of the Nebraska Furniture Mart. (Photograph by Carol McCabe.)

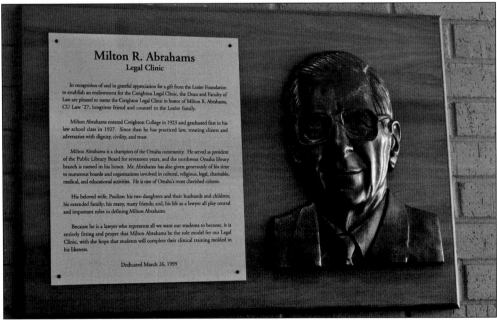

Omaha's Jewish community has strong ties with the Jesuit-run Creighton University. Creighton's distinguished local Jewish alums include Philip Klutznick, who headed the World Jewish Congress and endowed a chair of Jewish Civilization, and Milton R. Abrahams. A noted local attorney, Abrahams was the first editor of the student newspaper at Creighton and endowed the legal clinic for the poor at the law school, which was named in his honor. (Photograph by Carol McCabe.)

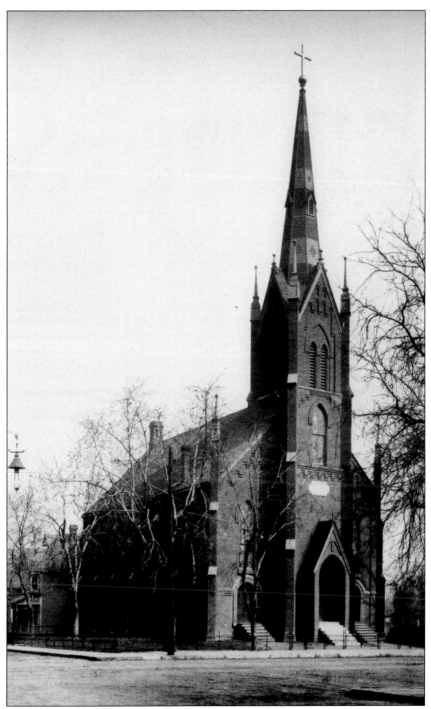

The Swedish Immanuel Lutheran Church was the outgrowth of mission work in 1886 by the Rev. J.A. Hultman, who came to Omaha on a concert tour, liked what he saw, and became a resident. The structure in this photograph was located on the northeast corner of Nineteenth and Cass Streets. The lot was purchased for $11,000, and the church was built for $12,000. (Courtesy of the Omaha Public Library.)

The Swedish Mission movement was founded in the 1880s in Sweden. Dissenters from the state-run Lutheran Church formed their own church. Members of this society arrived in Omaha in the late 1880s. The Swedish Mission Church shown here was located on the northeast corner of Twenty-third and Davenport Streets. The lot was purchased on May 11, 1887, for $11,800, and the building was completed in 1888. The church was renamed First Covenant Church of Omaha in 1927. (Courtesy of the Omaha Public Library.)

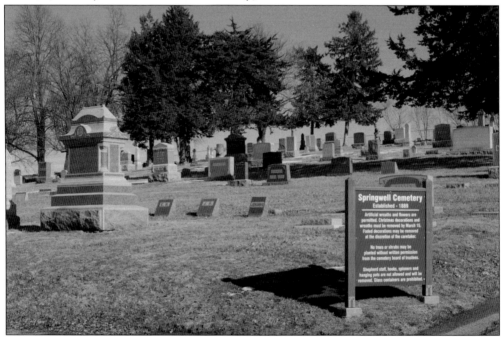

Springwell Cemetery, a historic Danish cemetery at Sixtieth and Hartmann Streets in North Omaha, demonstrates the way many ethnic groups centered around burial societies. Springwell was established in 1889 and was added to the list of Omaha Landmarks in 1996. (Photograph by Carol McCabe.)

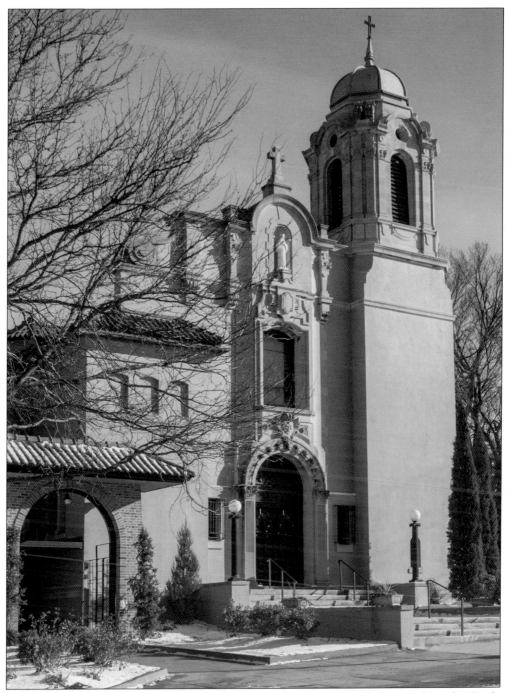

St. Frances Cabrini Catholic Church, at 1335 South Tenth Street, was the heart of Omaha's Little Italy neighborhood at the turn of the 20th century, when numerous Italians began arriving in Omaha. In 1910, there were about 2,300 Italians in the city, and the influx, mostly from Sicily, continued until World War I. The church is on the list of Omaha Landmarks as an example of Spanish Renaissance Revival style. It is also listed in the National Register of Historic Places. (Photograph by Carol McCabe.)

St. Frances Cabrini Church houses a noted statue of St. Lucy that is carried on a float through the streets of Omaha every year to the site of the Santa Lucia Festival. The statue was designed in Italy and brought to America in the early 1920s. Each year during the festival, the statue is decorated with gold and jewels donated by the faithful. Some of the items date to the early days of the festival. The festival was founded in 1925 and is sponsored by a variety of Italian American organizations, including the Sons of Italy, who participate in the parade, as seen below. (Both photographs by Carol McCabe.)

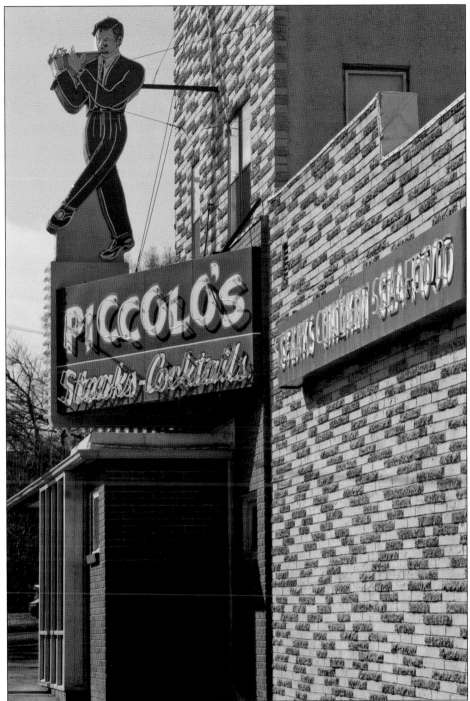

Omaha Italians are noted for their fine steakhouses, including Piccolo Pete's Restaurant, which has been in business at 2202 South Twentieth Street since 1933. The building had been a saloon that was forced to close during Prohibition but reopened after it ended. This classic local restaurant has been featured on cable television, and, like many local Italian restaurants, it offers pasta with its steaks. (Photograph by Carol McCabe.)

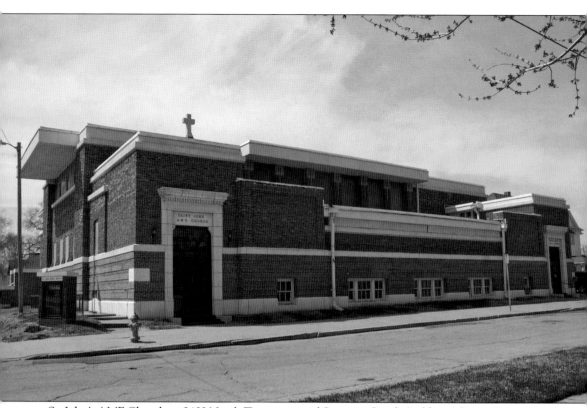

St. John's AME Church, at 2402 North Twenty-second Street, is Omaha's oldest African American congregation, organized in 1867. The church held services in a variety of downtown locations until moving to its current building in 1922. It is listed in the National Register of Historic places as an example of Prairie School architecture. African Americans began moving to Omaha during the territorial days, but the city experienced a major influx during World War I when job opportunities opened in the packinghouses. (Photograph by Carol McCabe.)

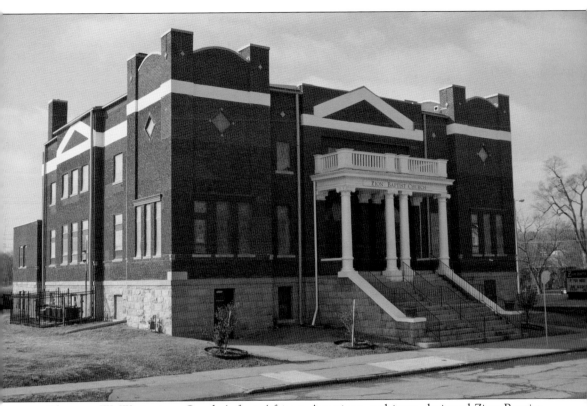

Clarence W. Wigington, Omaha's first African American architect, designed Zion Baptist Church, at 2215 Grant Street. Wigington began his career working for architect Thomas Rodgers Kimball, who designed St. Cecilia's Cathedral. Wigington also won an art contest at the 1898 Trans-Mississippi Exposition. (Photograph by Carol McCabe.)

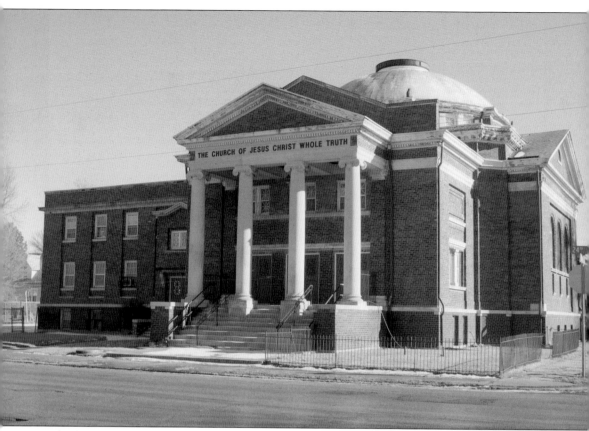

This historic church at 3105 North Twenty-fourth Street was built in 1910 as North Presbyterian Church. It was designed by Omaha architect F.A. Henninger as an example of neoclassical revival style that took its inspiration from the 1898 Trans-Mississippi Exposition. The church changed its name to Calvin Memorial Presbyterian Church and is designated as an Omaha Landmark. It is now known as the Church of Jesus Christ Whole Truth. (Photograph by Carol McCabe.)

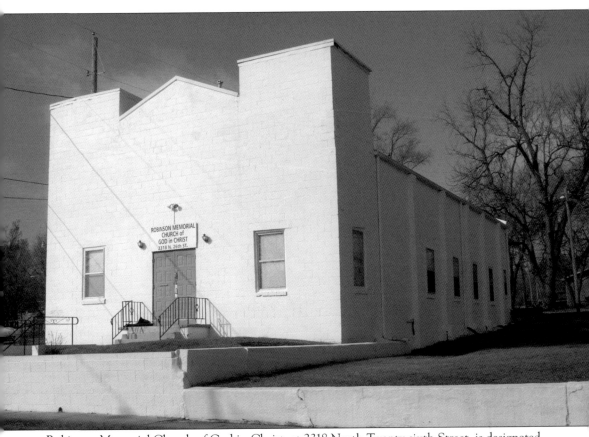

Robinson Memorial Church of God in Christ, at 2318 North Twenty-sixth Street, is designated as an Omaha Landmark. (Photograph by Carol McCabe.)

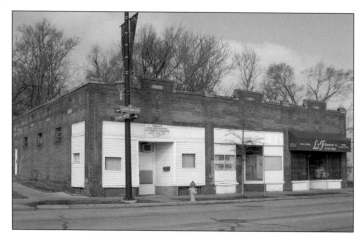

The New Beginning in Christ Church, at Twenty-fourth and Decatur Streets, is an example of the many storefront churches in North Omaha's African American area. This church is in a commercial stretch of Twenty-fourth Street and is a block north of another storefront church. (Photograph by Carol McCabe.)

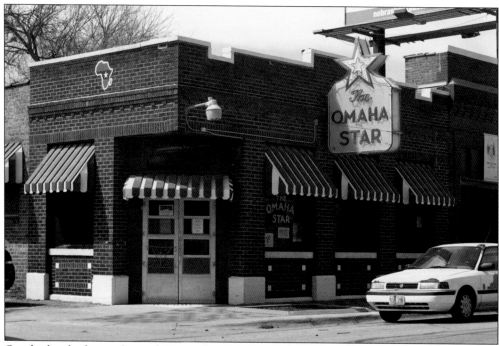

Omaha has had an unhappy history of segregation and racial conflict, including the notorious 1919 courthouse riot in which a prisoner was lynched. Among those battling segregation was Mildred Brown, longtime publisher of the *Omaha Star*. This photograph shows the Omaha Star Building, which is listed in the National Register of Historic Places. Brown's allies included Whitney Young, head of the local Urban League, who later headed the national Urban League, and the Rev. John Markoe, a Creighton Jesuit who mobilized the student DePorres Club. Other noted Omaha African Americans include jazz musician Preston Love and Omaha native Malcom X. (Photograph by Carol McCabe.)

Svaty Vaclava (St. Wenceslaus) Church, located at Tenth and Pine Streets, was the oldest wood-framed church in Omaha. It was built from 1887 to 1889 on the site of Kucera's Stop Over Tavern. The church was closed in 1981, and the parish moved to a new location at 154th and Pacific Streets. (Courtesy of the Omaha Public Library.)

"Historic Saint Wenceslaus Church Omaha, Nebraska"

ST. ADALBERT'S CHURCH AND SCHOOL, KOSTEL A ŠKOLA SV. VOJTĚCHA, OMAHA, NEBRASKA.

In September 1916, a group of 40 Czech families petitioned the Omaha archbishop to form a new Catholic parish. On October 10, 1917, St. Adalbert's was incorporated. This was the last parish in Omaha allowed to form as a "national" parish, with no physical boundaries but serving a specific nationality. The new facility on Thirty-first and Wright Streets was dedicated on September 12, 1919. The adjacent school opened in the fall of 1919 with 69 students. (Courtesy of the Omaha Public Library.)

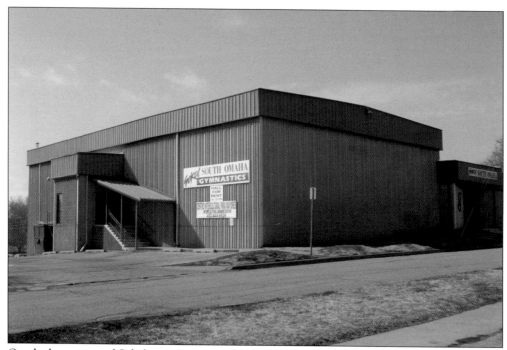

Omaha boasts several Sokol organizations, a Czech word meaning "Falcon." Founded as community centers, they featured gymnastics, singing, and dancing. This photograph shows the Sokol hall at Twentieth and U Streets, proclaiming it as the home of South Omaha gymnastics and the intercultural senior center. Omaha Olympic gold medal winner James Hartung began his gymnastics career at a Sokol hall. The Sokol hall at Thirteenth and Martha Streets is now a noted venue for local rock music. (Photograph by Carol McCabe.)

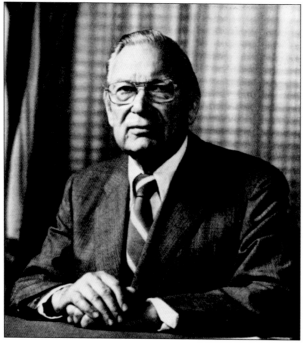

Nebraska has one of the nation's highest percentages of people of Czech descent. Many came to Omaha to work in the packinghouses and heard about the city through the Czech language newspaper that *Omaha Bee* editor Edward Rosewater sent back to his native land. Among Nebraska's noted Czechs was US senator Roman Hruska, who served from 1954 to 1976. (Courtesy of the Douglas County Historical Society.)

St. Stanislaus Catholic Church, at 4002 J Street, has been the heart of Omaha's Polish community since it was founded in 1919. Every year, it hosts a large Polish festival featuring ethnic delicacies such as pirogies, sausages, beer, and goliabki, as well as music and dancing. (Photograph by Carol McCabe.)

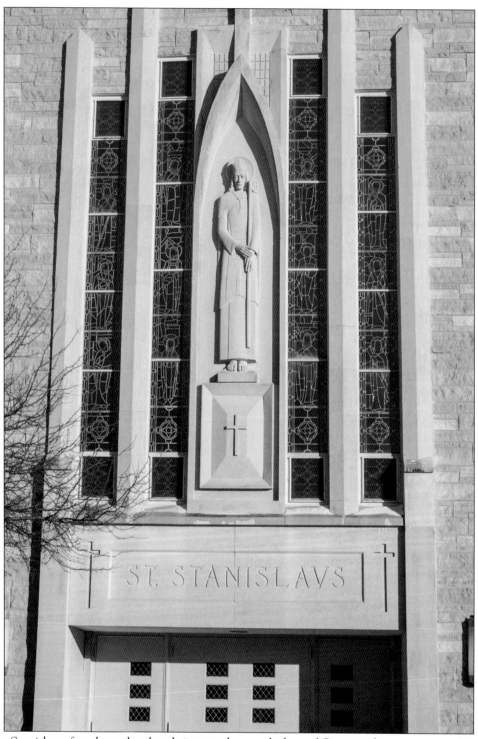

St. Stanislaus, for whom the church is named, was a bishop of Cracow who was martyred in a dispute with the king of Poland while he was saying Mass. He has long been a symbol of Polish nationhood. (Photograph by Carol McCabe.)

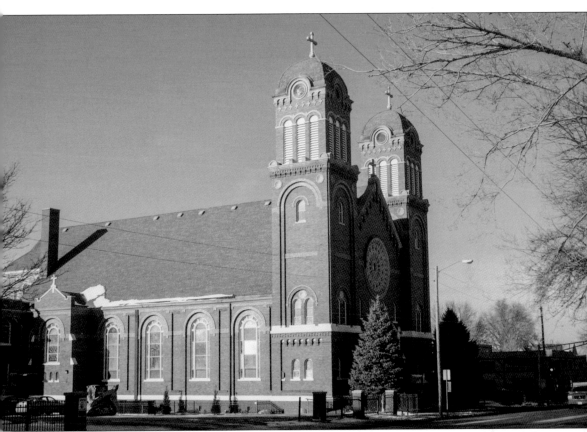

Immaculate Conception Church (ICC), at 2708 South Twenty-fourth Street, is a noted Polish parish built in 1926. The church is listed in the National Register of Historic Places. Just west of the church is the ICC recreation center, which features the Bowlatorium, one of the last church-operated bowling alleys in the United States. It hosts leagues, open bowling, and parties. (Photograph by Carol McCabe.)

Lithuanians, Croatians, Slovenians, and Hungarians were among the other Eastern European groups that came to South Omaha to work in the packinghouses. Today, Sts. Peter and Paul Church (above), at Thirty-sixth and X Streets, and St. Anthony's (below) function as one parish, worshipping at Sts. Peter and Paul. Sts. Peter and Paul was originally Croatian, and St. Anthony's was originally Lithuanian. (Both photographs by Carol McCabe.)

Romanians left their mark in South Omaha as well, with the now-closed St. Cross Romanian Orthodox Church, at Thirty-third and R Streets. The building's cornerstone is dated 1941. (Photograph by Carol McCabe.)

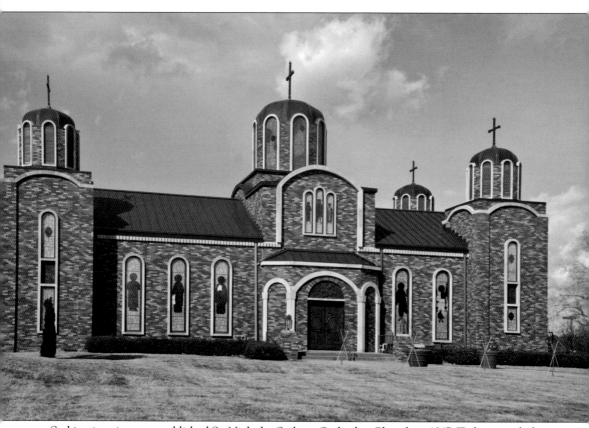

Serbian immigrants established St. Nicholas Serbian Orthodox Church in 1917. Today, it includes members of Serbian, Russian, and Bulgarian heritage, as well as others from southeastern Europe. It boasts that it is the only church in Omaha where worshippers can hear the gospel in four languages. This photograph shows the church at 5050 Harrison Street. (Photograph by Carol McCabe.)

Mexicans began arriving in Omaha after World War I to work in the packinghouses. In 1919, they opened Our Lady of Guadalupe in an old bakery shop at Twenty-first and Q Streets. It closed, reopened, and moved prior to the building of the current church in 1951 at 2310 O Street. Our Lady of Guadalupe is Omaha's largest Mexican American congregation. (Photograph by Carol McCabe.)

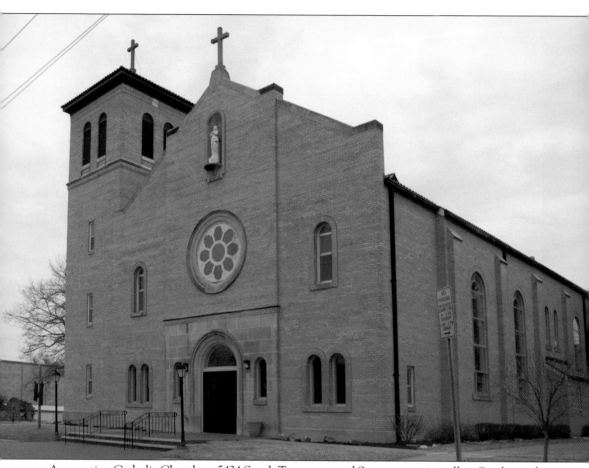

Assumption Catholic Church, at 5424 South Twenty-second Street, was originally a Czech parish but has since merged with Our Lady of Guadalupe Church. Masses, including many in Spanish, are held weekly at both locations. (Photograph by Carol McCabe.)

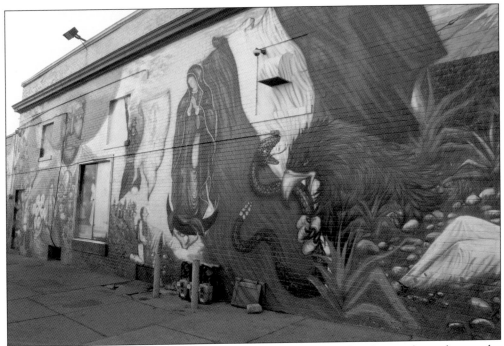

This street mural of Our Lady of Guadalupe at Twenty-fourth and N Streets shows the popular devotion to Mexico's patroness. (Photograph by Carol McCabe.)

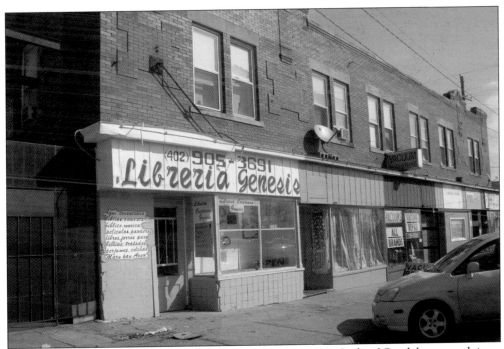

This Christian bookstore at 2320 N Street, across from the Our Lady of Guadalupe mural, is an example of both the piety of many Mexican Americans and the way they have transformed South Omaha into a vibrant ethnic commercial area. (Photograph by Carol McCabe.)

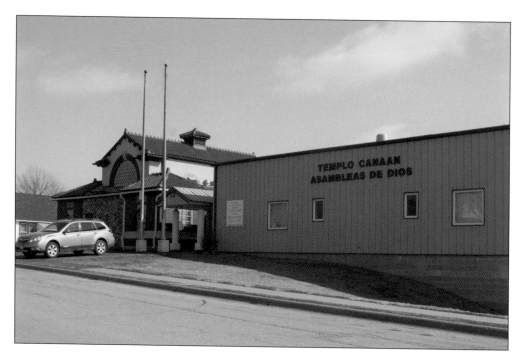

Templo Canaan Asambles De Dios, at 5223 South Twentieth Street, is an example of the small Hispanic churches of many denominations that are scattered throughout South Omaha. Some, such as Primera Iglesia Bautista (below), are storefront churches. (Both photographs by Carol McCabe.)

Four

OMAHA'S CHANGING RELIGIOUS LANDSCAPE

The religious landscape of Omaha is changing. A Harvard map charting the city's growing diversity found that in addition to Christian, Jewish, and Unitarian-Universalist congregations, today's Omaha includes centers of Afro-Caribbean spirituality, the Baha'i faith, Buddhism, Confucianism, Hinduism, Islam, the Jain religion, Native American religion and culture, Shintoism, and the Sikh and Zoroastrian faiths. There also are centers for paganism, atheism, and humanism.

A drive around the city provides ample evidence of these changes, from a colorful Buddhist shrine just off Sorensen Parkway in North Omaha to a spectacular Hindu temple in West Omaha. Many of the smaller religious centers are tucked away in homes in residential areas, such as the Nebraska Zen Center in the Bemis Park neighborhood or the Baha'i Center in a modest frame house in west central Omaha.

The changes in Omaha's religious composition reflect the immigrants from Latin America, the Middle East, and Asia who have settled in the city in the past 25 or 30 years. An influx of Hispanics has transformed South Omaha's downtown into a thriving Latin-themed retail area. Our Lady of Guadalupe Church, Omaha's historic Mexican-American parish in the heart of South Omaha, has expanded, and other South Omaha parishes such as St. Agnes Church are now heavily Hispanic. Mexican-American Protestant storefront churches, many with Spanish names, dot the streets.

Exciting new projects reflect the city's acceptance of people of diverse religious heritages. Project Interfaith, founded by Beth Katz, a Jewish alumna of Creighton University, promotes creative religious interchanges with programs ranging from interviews to speed dialoguing. It combats conflict perpetuated by ignorance, stereotyping, and marginalization.

Omaha's diverse religious community has come a long way since pioneer days, when Catholics and Episcopalians carried their shared organ between their worship spaces. But the spirit of faith, and the respect for the faiths of others, is unchanged.

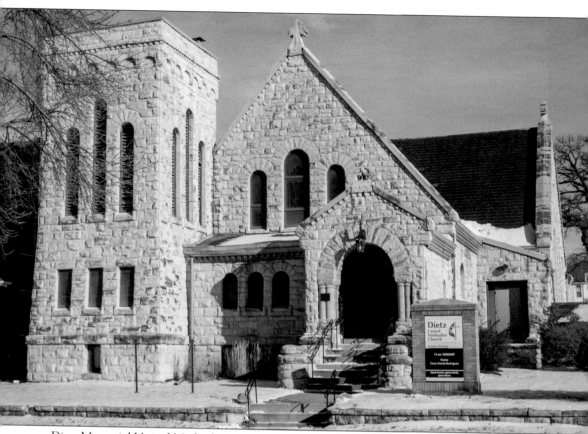

Dietz Memorial United Methodist Church, at 1423 South Tenth Street, is listed in the National Register of Historic Places. It was designed by architect J.H.W. Hawkins and was historically known as St. Mathias Episcopal Church. The church opened in 1889 and is an example of Romanesque Revival architecture. (Photograph by Carol McCabe.)

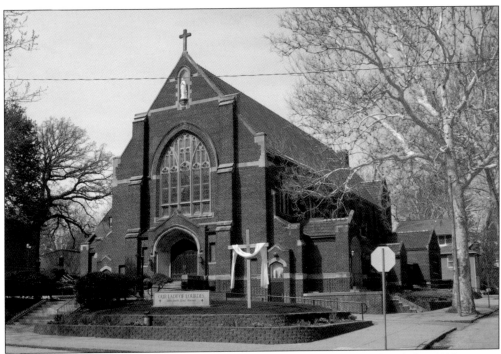

Our Lady of Lourdes Church, at 2110 South Thirty-second Avenue, was founded in 1918, serving the Hanscom Park and Field Club neighborhoods. The parish is now paired with St. Adalbert's Catholic Church (below), on Thirty-first and Wright Streets, which serves both its neighborhood and the Korean Catholic community. A Mass in Korean is held every Sunday, and a Korean priest is in residence at St. Adalbert's, originally a Czech parish. (Both photographs by Carol McCabe.)

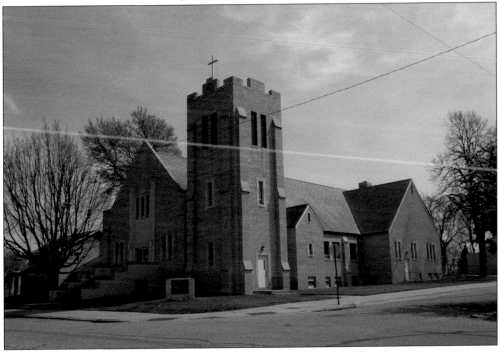

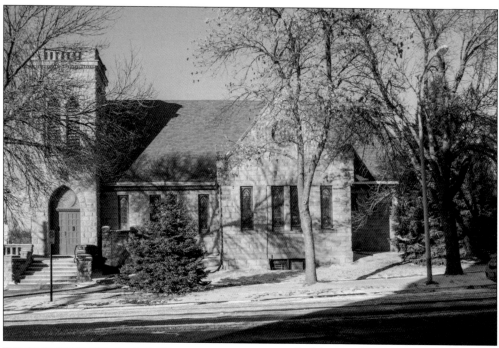

St. Martin of Tours Episcopal Church, at 2312 J Street, is listed in the National Register of Historic Places. The congregation was founded in 1876, and its architecture evokes the historic Christian church styles of the Middle Ages. It is also designated as an Omaha Landmark. (Photograph by Carol McCabe.)

The Notre Dame Academy and Convent, at 3501 State Street in the Florence area, is listed in the National Register of Historic Places. The Sisters of Notre Dame purchased the site, Seven Oaks Farm, from Father Edward Flanagan of Boys Town. Architects Matthew Lahr and Carl Stanegel designed the E-shaped convent and school in the late Italian Renaissance Revival style, which was influenced by the architecture of the Trans-Mississippi Exposition. For years, it housed Notre Dame Academy, a girls' school, and much of it is now housing for the elderly. (Photograph by Carol McCabe.)

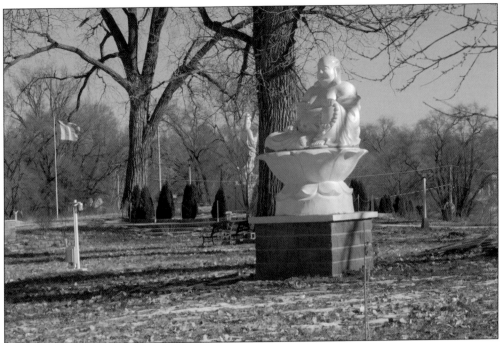

This Buddhist statuary garden is located just south of the Sorensen Parkway in North Omaha. It is a peaceful setting visible from the busy highway. (Photograph by Carol McCabe.)

There are several Baha'i communities in the greater Omaha area, including this Baha'i center at 5114 North Sixtieth Street. The Baha'i faith was founded in Iran in 1844 and preaches the message that humanity is a single race and that the day has come to unite people into one global society. (Photograph by Carol McCabe.)

The Nebraska Zen Center, at 3625 Lafayette Avenue, is a Soto Zen Buddhist temple that follows a Japanese tradition dating to the 13th century. The center was established in 1975 and includes indoor and outdoor spaces for meditating. (Photograph by Carol McCabe.)

The new religious congregations in today's Omaha include this Unification church located in an inconspicuous house in a residential area near Fifty-fifth and Cedar Streets. The Unification Church is a worldwide body founded by Rev. Sun Yung Moon. (Photograph by Carol McCabe.)

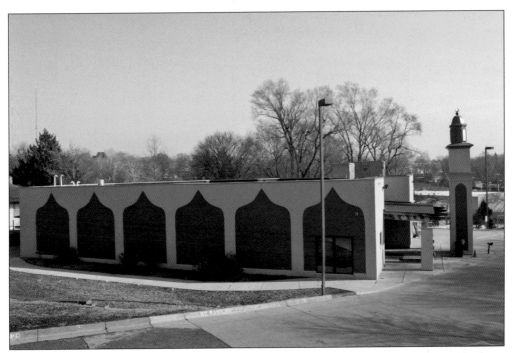

The Islamic Center of Omaha, at 3511 North Seventy-third Street, features a minaret topped by a crescent and cultivates unity among Omaha's Muslims. The center describes itself as an independent, nonprofit Islamic organization that is dedicated to promoting understanding of the faith among both Muslims and non-Muslims, along with mutual respect. The center also supports Muslim families arriving in Omaha. (Photograph by Carol McCabe.)

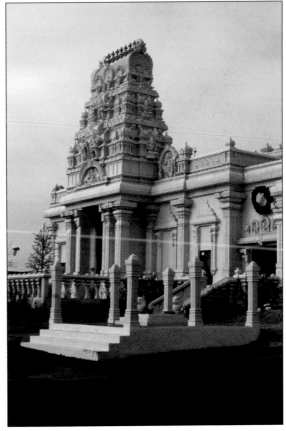

The Hindu Temple of Omaha opened in 1993. The Hindu community in Nebraska dates to the early 1970s, when an influx of engineers and other immigrants were employed in tech industries. They constructed this spectacular traditional Hindu temple at 13010 Arbor Street in 2004. The facility includes a temple, a social hall, and a library. Members of the temple are active in Omaha and Lincoln interfaith activities to promote understanding of Hindu beliefs and traditions. (Photograph by Carol McCabe.)

Dundee Presbyterian Church, at 5312 Underwood Avenue, occupies a prominent position on the west edge of the historic Dundee–Happy Hollow neighborhood. The church was organized in 1901 and built this impressive structure in 1928. Warren Buffet was married at Dundee Presbyterian, one of many prominent Omahans associated with the congregation. (Photograph by Carol McCabe.)

Only a handful of historic Omaha churches have official historic landmark status, but some, like St. Margaret Mary Church, at Sixty-first and Dodge Streets, across from the University of Nebraska at Omaha, are unofficial landmarks. The parish was organized in 1919 at 5002 California Street and moved to its current building, shown above, in 1951. However, the original parish facility (below) still stands near Fiftieth and California Streets and has been converted to apartments. (Both photographs by Carol McCabe.)

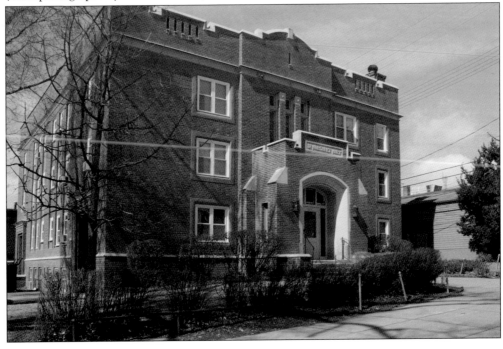

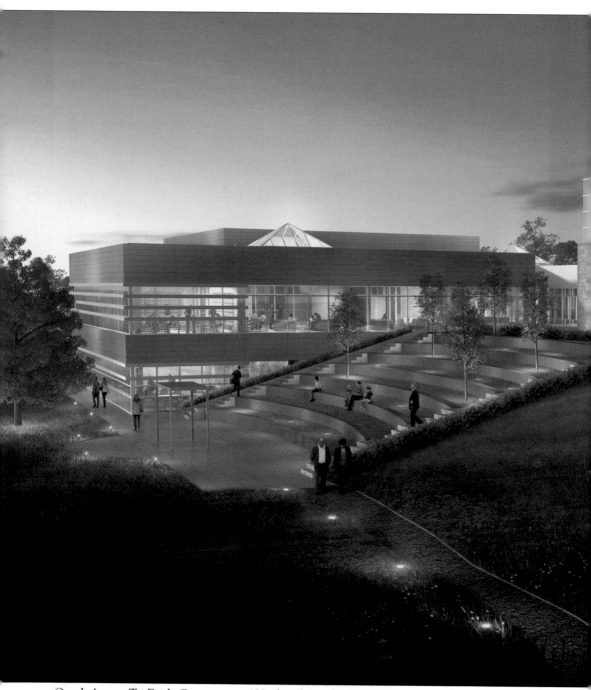

Omaha's new Tri-Faith Center, near 132nd and Pacific Streets, is an innovative concept that eventually may house Temple Israel, a Christian church, an Islamic mosque, and a community center for interfaith activities. An architect for the project commented that "there is no place in

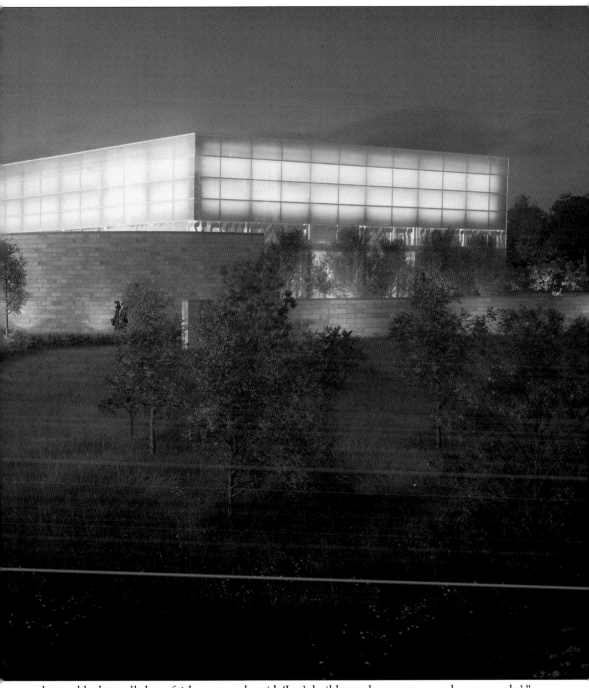

the world where all three faiths purposely said, 'Let's build together so we can educate people.' "
(Courtesy of Finegold Alexander + Associates Inc., Architects.)

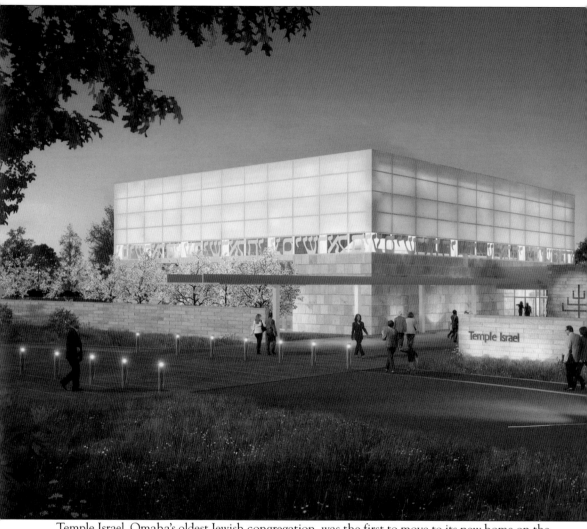

Temple Israel, Omaha's oldest Jewish congregation, was the first to move to its new home on the Tri-Faith campus. This architectural rendering shows the exterior of the new synagogue. (Courtesy of Finegold Alexander + Associates Inc., Architects.)

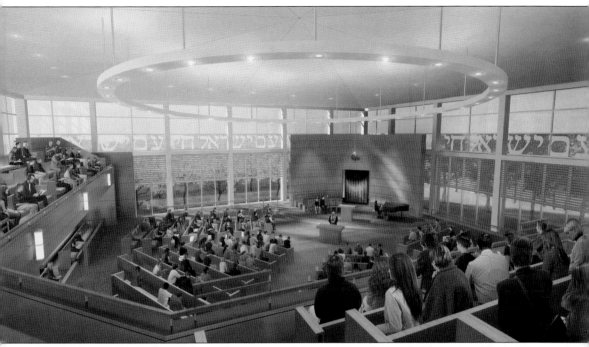

This architectural rendering shows the interior of the new Temple Israel. (Courtesy of Finegold Alexander + Associates Inc., Architects.)

DISCOVER THOUSANDS OF LOCAL HISTORY BOOKS FEATURING MILLIONS OF VINTAGE IMAGES

Arcadia Publishing, the leading local history publisher in the United States, is committed to making history accessible and meaningful through publishing books that celebrate and preserve the heritage of America's people and places.

Find more books like this at
www.arcadiapublishing.com

Search for your hometown history, your old stomping grounds, and even your favorite sports team.